BY FABER BIRREN

PRINCIPLES OF COLOR

REVIEW OF PAST TRADITIONS AND MODERN THEORIES OF COLOR HARMONY

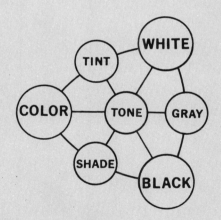

VNR VAN NOSTRAND REINHOLD COMPANY
New York Cincinnati London Toronto Melbourne

Van Nostrand Reinhold Company Regional Offices: New York, Cincinnati, Chicago, Millbrae, Dallas
Van Nostrand Reinhold Company International Offices: London, Toronto, Melbourne

Type set by Lettick Typografic Company, Inc. Published by Van Nostrand Reinhold Company
Printed by Halliday Lithograph Corporation 450 West 33rd Street, New York, N.Y. 10001
Color printed by Princeton Polychrome Press Published simultaneously in Canada by
Bound by Publishers Book Bindery, Inc. Van Nostrand Reinhold, Ltd.

5 7 9 11 13 15 16 14 12 10 8 6 4

Contents

Introduction

This is meant to be an elementary book on color. Written by the best known colorist of his time, it deals with traditional principles of harmony as well as advanced principles derived from modern studies of the psychology of perception — a field that has made Faber Birren one of the most original thinkers in today's world of color expression.

The writer may well be called a practical theorist, concerned not only with abstract concepts of the elements of beauty but with ways in which these elements can be put to use in the fine and commercial arts. What is important are not rules or observance of rules, but an understanding of the human and personal nature of color. This book seeks to inspire, not conformance to color law (where it may happen to exist), but to knowledgeable release for the artist and designer.

Color is a progressive art. There are new materials from the laboratory of the chemist, better and more permanent pigments and dyestuffs. Demand for color has been greatly expanded. In commercial fields, television, motion pictures, packaging, there is a constant quest for more compelling uses of color. In interior design greater facility with color is being demanded for just about every habitat of man, from homes to factories to offices, to hospitals, schools, ships, airplanes — and soon underground and underwater laboratories and living spaces.

In the fine arts, there is a recent end to uninhibited indulgence of the spectrum. There is a cycle and return to the disciplines of the late nineteenth century. Fine art today is again concerned with science, but the science this time is that of the psychologist rather than the physicist.

In its design and interest, this book tells a well organized story of how to achieve harmony with color. It begins with a chapter on color circles and how

leading colorists of the past have sought to build order out of chaos.

It then proceeds to a simple and straightforward discussion of traditional principles of color harmony and how they were accepted in the past. A chapter on "The Harmony of Color Forms" suggests further devices to assure beauty, as built upon psychological and wholly natural paths of color arrangement. This approach is new to the art of color and has rapidly become part of modern color training and education.

Finally, there are advanced principles of beauty which attempt to venture in new directions. Research in gestalt psychology, in the mysteries of perception, has opened up new sources of expression which Faber Birren has very ably interpreted and reduced to plain terms.

The publisher hopes and expects this book to become an essential text in color education. It is in one sense a book for beginners and in another sense a refresher course for those of greater competence and longer experience. To those who are starting out, it offers a thorough grounding — traditional and modern — in the comprehension and solution of color harmony problems. To the mature artist and designer it offers a chance to check on recent findings and conclusions — on data and ideas which may have come to light since his own tyro days.

Faber Birren

He was born in Chicago in 1900. His mother was a skilled musician and his father a successful painter. The elder Joseph Birren was something of a prodigy in the field of art. As a youth he worked on cycloramas of the Battle of Gettysburg, and studied in Munich and at the Académie Julian in Paris (which also had counted Albert H. Munsell as a student). He was founder and first president of the alumni association of the school of the Art Institute of Chicago.

Faber Birren attended the Institute school from the age of about twelve to twenty. He then spent two years at the University of Chicago (1920-21) where he attended a course on color theory for art teachers and art supervisors conducted by a Chicago painter, Walter Sargent, in the School of Education. Here his interest in color had its beginning.

Faber Birren has since become the best-known and most widely read color authority of his time. He has authored over a score of books and several hundred articles for general, professional, and scientific publications. Perhaps the most informative account of his life can be written around his books:

1928. Faber Birren wrote his first book, *Color in Vision*. This was followed in 1934 by *Color Dimensions* and *The Printers' Art of Color*.

1937. He wrote *Functional Color* and set about to become one of the fore-

most experts on visual, physiological, and psychological aspects of color.

1938. *Monument to Color*, profusely illustrated in color, and now a collector's item, came as the result of his art training and introduced new principles of color expression based on scientific studies of human perception.

1941. *The Story of Color* is a general review of every aspect of color in human life — science, art, medicine, religion, mysticism. (Revised and reprinted in 1963 as *Color: A Survey in Words and Pictures.*)

1948. Faber Birren developed manuals of standard color practice for the shore establishments, surface vessels, and submarines of the U. S. Navy. This was followed in 1952 by a similar report for the U. S. Coast Guard, and in 1966 by a report for the U. S. Army.

1948. With the help of other artists, Faber Birren created and assembled a series of unusual color studies which he termed "Perceptionism," and which were exhibited in New York at the National Arts Club, in Chicago at the Art Institute of Chicago, and in other cities.

1950. He wrote *Color Psychology and Color Therapy*. This has become a classic in its field. Reprinted in 1961.

1955. He published *New Horizons in Color*, devoted to color problems in architecture.

1955. The U. S. Department of State sent him as an expert on functional color to an International Congress in Rome on work productivity and safety.

1961. *Creative Color* appeared. Now a standard work on color training.

1963. *Color for Interiors* reviews the history of color tradition.

1965. *History of Color in Painting*, a major work, was issued. It gathers together the rich heritage, experience, and scholarly knowledge of a man who has become pre-eminent in his chosen world.

1967. *The Principles of Harmony and Contrast of Colors*, M. E. Chevreul's monumental masterwork, edited by Faber Birren, was published. This work is discussed in "The Harmony of Colors" and in the reference section.

History of Color Circles

In classical times such scholars as Pythagoras, Plato, Aristotle, Pliny discoursed on the nature of color. Aristotle, for example, wrote: "Simple colors are the proper colors of the elements, i.e., of fire, air, water, and earth." They were created by blends of darkness and light: "Black mixed with sunlight and firelight turns crimson."

Curiously, some eighteen centuries later Leonardo da Vinci held more or less the same view. The following remarkable statement is to be found in his *Treatise on Painting*. "The first of all simple colors is white, though philosophers will not acknowledge either white or black to be colors; because the first is the cause, or the receiver of colors, and the other totally deprived of them. But as painters cannot do without either, we shall place them among the others; and according to this order of things, white will be the first, yellow the second, green the third, blue the fourth, red the fifth, and black the sixth. We shall set down white for the representative of light, without which no color can be seen; yellow for the earth; green for water; blue for air; red for fire; and black for total darkness."

Yet while da Vinci observed that yellow and blue formed green, no systematic attempt was made to organize colors until more than another century had passed. It was then, around 1660, that Sir Isaac Newton revealed the true nature of color and devised the first of all color circles. (See Figure 1.)

According to Newton all colors were contained in white light. White light, in fact, was made up of bundles of rays of atoms which the prism could separate. The atoms for red were large, while the atoms for blue and violet were small. Being something of a mystic as well as a scientist, Newton chose seven principal colors and allied them to the proverbial seven spheres or planets and to the seven notes of the diatonic scale in music: red (note C), orange (note

D), yellow (note E), green (note F), blue (note G), indigo (note A), and violet (note B). If science no longer counts seven hues in the spectrum, poets and romanticists still do.

Although the spectrum ran in a straight band from red to violet, Newton did the ingenious thing of twisting it into a circle (Figure 1). In the *physical* sense, red and voilet were opposite. Visually, however, they bore resemblance. The connecting link was purple: "The Colour compounded shall not be of any of the prismatick Colours, but of a purple inclining to red and violet." In other words, there were no specific rays and atoms for purple, this color being seen when red and violet were blended.

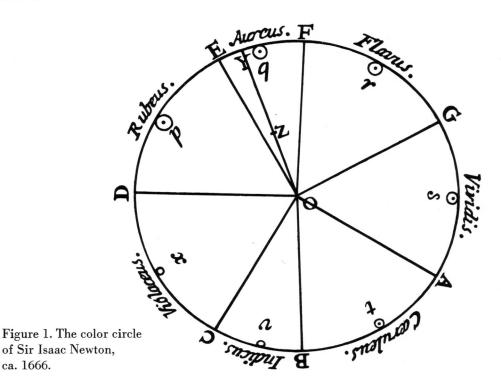

Figure 1. The color circle of Sir Isaac Newton, ca. 1666.

Figure 2. Page from
Le Blon's treatise, 1756,
describing the primary
nature of red, yellow, blue.

THE RED, YELLOW, BLUE THEORY

In less than another century (ca.1731) a man by the name of J. C. Le Blon discovered the primary nature of red, yellow, and blue in pigment mixtures — a fact that seems all too obvious today. Yet as an English writer declared in 1731, "That invention has been well approv'd thro'out Europe, tho' at first it was thought impossible." This was the beginning of the red, yellow, blue theory.

Figure 2 reprints a page from a treatise by Le Blon published in 1756. It is perhaps the first printed statement of the fundamental nature of red, yellow, blue.

A decade or so later (ca.1766) Morris Harris, an English engraver who was also an entomologist, published the first color chart ever to appear in full hue — and it featured the red, yellow, blue theory. (See Figure 3.) The chart appeared in a book, *The Natural System of Colours,* which is exceedingly scarce, probably no more than two or three copies having survived. (The book was reprinted in facsimile with an introduction by Faber Birren in 1963.)

Harris spoke of prismatic or primitive colors (red, yellow, blue), mediate colors (orange, green, purple), and compound colors which artists today call tertiaries, olive (orange + green), slate (green + purple), and brown or russet (purple + orange).

Figure 3. The color circle of Moses Harris, ca. 1766.

Figure 4. The color circle of
Ignaz Schiffermuller, 1772.

Shortly after, in 1772, one Ignaz Schiffermuller of Vienna composed a
beautifully illustrated color circle. (See Figure 4.)

Now the theory was broadly accepted and was taken up by a long series of
scientists, artists, and philosophers. In Germany there was Philipp Otto Runge
and the eminent poet Johann Wolfgang von Goethe. Goethe, however, con-
sidered yellow and blue to be primary. As believed by Aristotle centuries
before, yellow came out of lightness and blue out of darkness. All other colors,
including red, were blends of them.

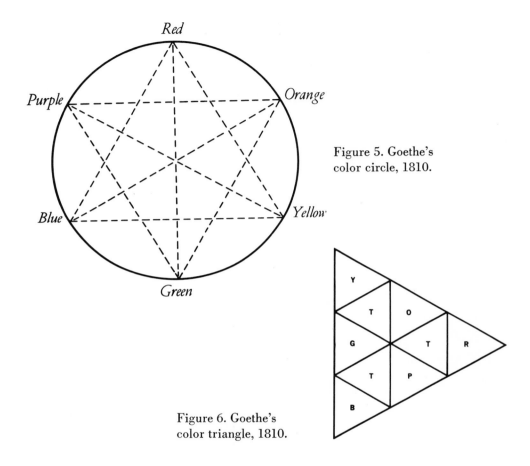

Figure 5. Goethe's color circle, 1810.

Figure 6. Goethe's color triangle, 1810.

Goethe arranged his colors on a color circle (Figure 5) as well as on a triangle (Figure 6). His contemporary, Philipp Otto Runge, a remarkably talented painter, also put red, yellow, blue on the angles of a triangle (Runge designed, as well, the first significant and important color solid, a sphere on which all colors, tints, tones, and shades of colors could be included in orderly fashion.)

14

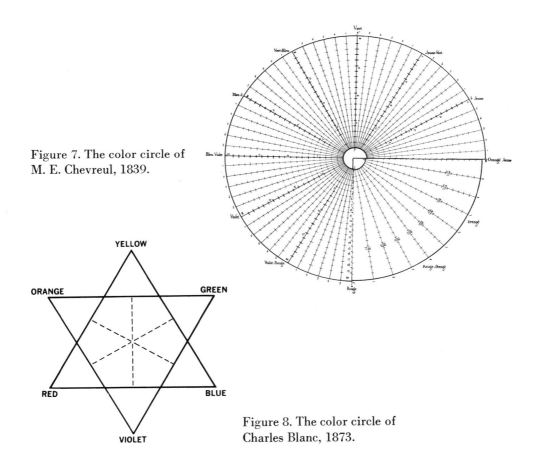

Figure 7. The color circle of
M. E. Chevreul, 1839.

Figure 8. The color circle of
Charles Blanc, 1873.

In France, M. E. Chevreul, one of the greatest colorists of all time, and whose work will be mentioned later in this book, featured the red, yellow, blue theory and was an important influence in the French painting schools of Impressionism and Neo-Impressionism (See Figure 7.) Charles Blanc, who was also revered by the Neo-Impressionists, gave his color circle the shape of a six-pointed star. (See Figure 8.)

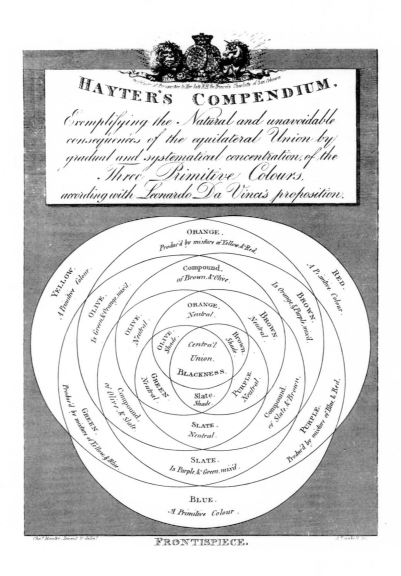

Figure 9. The Color Compendium of Charles Hayter, 1826.

In England, Thomas Young compounded a theory of color vision based on red, yellow, blue, which later was changed to red, green, blue when the theory was further developed by the German scientist Helmholtz. Charles Hayter designed a Color Compendium of red, yellow, blue in 1826. (See Figure 9.)

The red, yellow, blue doctrine became known as the Brewsterian Theory when, in 1831, Sir David Brewster, the great Scottish physicist gave it his blessing (erroneously). "I consider that the solar spectrum consists of three spectra of equal lengths, viz. a *red* spectrum, a *yellow* spectrum, and a *blue* spectrum."

In America, the red, yellow, blue color circle will be found in the books and works of Louis Prang, Milton Bradley, Arthur Pope, Herbert E. Ives. Most of these men have been prominent educators and their efforts have more or less made the red, yellow, blue theory part and parcel with American color and art education. The red, yellow, blue color circle, with refinements, has been chosen for this book and will be found typically illustrated in Figure 19 and Color Plate I.

OTHER COLOR CIRCLES

While the red, yellow, blue color circle has been favored by and large by artists and educators and is oldest of all color circles in concept, the physicist and phychologist have had other ideas. Though less numerous, several color circles have been based on the red, green, blue (or blue-violet) primaries of light. If red, yellow, blue will form most other colors in *pigments*, red, green, and blue will do likewise in *light rays*. This will be explained later in this chapter.

The red, green, blue primaries of light were first discovered around 1790. They were accurately identified, established, and measured by scientists such as Hermann von Helmholtz of Germany and James Clerk Maxwell of Great Britain. In 1879 Ogden Rood, physicist at Columbia College in New York

Figure 10. The color circle of Ogden Rood, 1879.

Figure 11. The color circle of Wilhelm von Bezold, 1876.

and one of the most eminent of American color authorities, developed a color circle (and a color solid) based on red, green, blue primaries. This is shown in Figure 10. Note that the center is white, and all pure hues on the outer circumference scale to white.

A. H. Church and R. A. Houstoun of England followed with red, green, blue circles. Wilhelm von Bezold of Munich created the color circle shown in Figure 11. His book on *The Theory of Color* was published in England in 1876 by Louis Prang of Boston. The triangle in the center points to vermilion, green, and bluish violet. Otherwise on the outer circumference the colors are spaced as to *apparent* difference. Opposites or complements are found in vermilion (red) and bluish green, orange and turquoise blue, yellow and ultra-

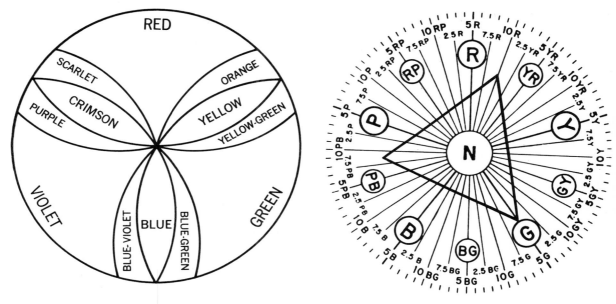

Figure 12. The color circle of Michel Jacobs, 1923.

Figure 13. The color circle of Albert H. Munsell, 1898.

marine, yellowish green and purplish violet, and green and purple. This chart fairly well plots both the primaries of light rays and good *visual* complements.

In 1923, Michel Jacobs, a well known American painter and teacher, wrote a book, *The Art of Color,* in which he worked out an elaborate theory and set of principles of color harmony based on red, green, violet primaries. (See Figure 12.) The violet he used was, in reality, a blue-violet similar to that used by Helmholtz, von Bezold, and others. Although he wrote of paints and pigments — which answer to red, yellow, blue mixtures — he also mentioned "scintillating" effects in which dots or spots of color were intermingled to get visual and therefore presumed light mixtures.

The color circle of Albert H. Munsell, shown in Figure 13, also traces to the primaries of the physicist. If three equidistant points, starting with green, are located on the Munsell circle the other two points will touch a red having a small part of yellow (vermilion) and a purple blue. Munsell recognized this and deliberately planned his circle accordingly.

As to color circles, there is the third concept of the psychologist in which red, yellow, green, blue are primary. It is quite true that a certain red, a certain yellow, a certain green, and a certain blue are "unitary" and have no visual resemblance to each other. Ewald Hering, a German physiologist, supported this selection around 1870 and it since has been fully accepted by psychologists.

Having assumed that the eye responded primarily to red, yellow, green, and blue, he designed the color circle shown in Figure 14. (H. Aubert had

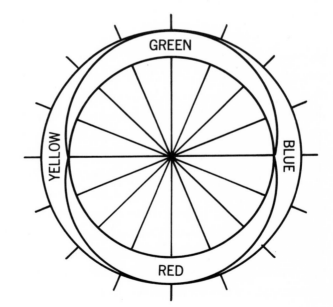

Figure 14. The color circle of Ewald Hering, ca. 1878.

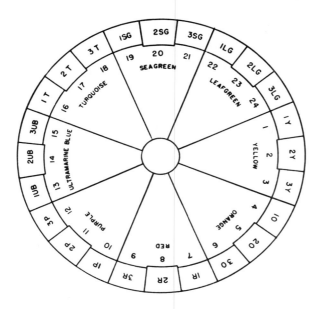

Figure 15. The color circle of Wilhelm Ostwald, 1916.

expressed the same idea in 1865.) Colors appeared essentially reddish, yellowish, greenish, or bluish. These four, with white and black, were all primitive or principal in human sensation. For example, while orange might look like red and like yellow, red and yellow did not look like orange. Purple likewise resembled red and blue, but red and blue were individual. While green in pigments might be formed with yellow and blue, "no one would assert that a green can be clearly both yellowish and bluish."

Hering's theories became more or less the basis of the color system of Wilhelm Ostwald. Indeed, the key points of Ostwald's color circle are red, yellow, sea green, blue, (Figure 15). Intermediates are orange, leaf-green, turquoise, and purple. In addition, Ostwald verified Hering's remarkable observation that the natural symbol of color was a triangle, with pure color on one angle, white on the second, and black on the third. Any and all modifi-

cations of a given hue could be plotted within the confines of this triangle. (See chapter on "The Harmony of Color Forms.")

The Hering-Ostwald approach to color has had many supporters and has been featured in a number of books. Notable are the works and writings of Arthur B. Allen, J. A. V. Judson, and J. Scott Taylor, all of England, and Egbert Jacobson of the United States. Ostwald himself was quite prolific and wrote several books on color.

ELEMENTS OF COLOR MIXTURE

There are three sets of primary colors and therefore three good reasons for different types of color circles. (Refer to Figure 16.) With *pigments*, red, yellow, blue are elemental and will, under normal conditions, form other hues. Such mixtures are subtractive and tend to go deep. And a combination of all three pigment primaries will form black or a deep brown.

With *light rays*, red, green, and blue (blue-violet) will form other hues. Red and green will form yellow. Green and blue will form a turquoise blue (cyan), while red and blue will form a magenta. In process printing and color reproduction, the light primaries of the physicist and the pigment primaries of the artist are brought together. The plate to print yellow is photographed through a blue filter. The plate to print red (magenta) is photographed through a green filter. The plate to print blue (cyan) is photographed through a red filter. Light primaries are additive, and all three combined will form white.

In *vision*, the primaries are red, yellow, green, blue. Mixtures, such as on a color wheel, tend to be medial. All four colors mixed or spun together will form gray.

This book uses a red, yellow, blue color circle, the elements of which will be described in the beginning of the next chapter. This tradition — with certain modifications — is still a sound one. It is academic and unreasonably

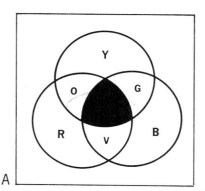

Figure 16. Pigment primaries are subtractive.

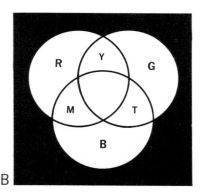

The primaries of light are additive.

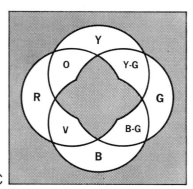

The primaries of vision are medial.

23

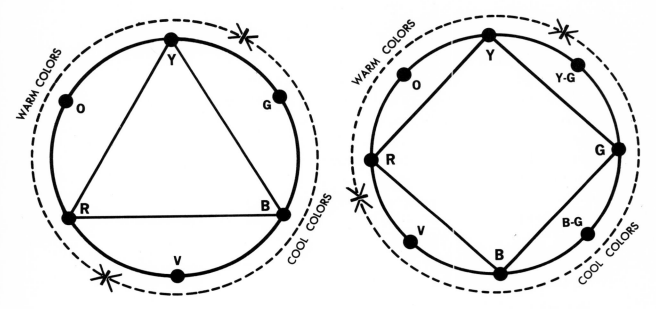

Figure 17. Relative distribution of warm and cool colors on two types of color circles.

specious to insist that certain primaries and certain pairs of opposites are right and others wrong. *All color circles for the most part are satisfactory for color harmony purposes, the red-yellow-blue circle, the Munsell circle, the Ostwald circle, or any other.*

This writer's preference for the red, yellow, blue circle is simply explained and illustrated in Figures 17 and 18. First of all, because the average artist or designer works with pigments or dyes, a choice of red, yellow, and blue makes sense. Further, the particular hue of the red, yellow, blue — and their secondaries and intermediates — can be adjusted to agree with visual laws of color arrangement. (The primaries of the physicist are of little consequence here.)

As to distribution of warm and cool colors (see Figure 17), with the red,

yellow, blue circle there is a fairly even distribution of warmth and coolness. However, with the red, yellow, green, blue circle, the warm region of the circle is condensed and the cool region enlarged.

Most artists and designers will give more importance to warm colors than to cool ones because of their more dynamic qualities and their stronger chroma or intensity. Indeed, as far as the facts of vision go, the eye can see more warm colors than it can cool ones! If a color circle were to be made rational, if its steps around the circumference were to be neatly ordered and smoothly perceptible, one to the next, such a circle would need to include more warm hues than cool ones, even if this sequence threw the central complementation point off balance. (See Figure 18.)

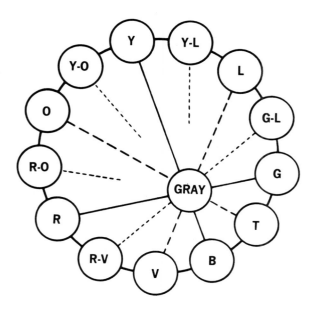

Figure 18. The Rational Color Circle designed by Faber Birren, 1934. L refers to leafgreen and T to turquoise.

The Harmony of Colors

Figure 19 and Color Plate I show the color circle suggested to carry out the color principles described in this book. Technically, the kind of red, yellow, blue chart used in process printing and the one brought to perfection some years ago by Herbert E. Ives should have a magenta for red (called *achlor* by Ives), a clear, clean yellow (called *zanth*), and a turquoise or peacock blue (called *cyan*). These particular three will, in combination, form a tolerably good spectrum of pure hues, but not an ideal one by any means.

The traditional red, yellow, blue circle of the artist has the same clear yellow as with Ives. However, the red is less of a magenta than a crimson or cadmium, and the blue is less of a turquoise than a cobalt or cerulean blue.

Yet a truly brilliant spectrum cannot possibly be mixed with three colors only, no matter what three are chosen. As far back as 1766, Moses Harris, who developed the first circle ever to be exhibited in full color, remarked that while the three principal colors would make fair intermediates, the results were likely to be "dirty and unmeaning." He wrote, "Suppose an orange color was wanted, red and yellow will effect it . . . but red-orange and yellow-orange mixed will do much better." And so it was with green, purple, and other pure hues. The artist who seeks true brilliance of color should have on his palette — in addition to primary red, yellow, blue — such other vivid pigments as vermilion, cadmium orange, lemon yellow, ultramarine blue, cobalt violet — plus the new phthalocyanine blues and greens and the new monastral reds.

Thus the colors on Color Plate I (and charted in Figure 19) consist of a slightly purplish red, a red-orange, a brilliant orange, a yellow-orange, a clear yellow, a vivid yellow-green, a "grassy" green, a cool blue-green, a "true" blue, a rich blue-violet, a deep violet, and an intense red-violet or

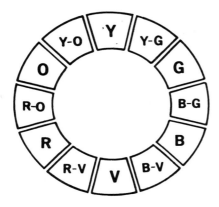

Figure 19. The red,
yellow, blue color circle.
(Also see Color Plate I.)

Figure 20. Title page of
masterwork on color by
M. E. Chevreul, 1839.

purple. Complementary relationship — opposites on the color circle, such as
red-green, yellow-violet — strike a compromise between pigment mixtures
that cancel into gray or a muddy brown, and visual mixtures that will do
likewise if spun on a color wheel.

M. E. CHEVREUL — PIONEER

One of the greatest names in the history of color is that of Michel Eugène
Chevreul (1786-1889). He lived to be 103 years of age, was director of the
dye house at the Gobelins tapestry works outside Paris, one of the foremost
chemists of his day, and author of a phenomenal book, *The Principles of
Harmony and Contrast of Colors*. (The original French title which dates to

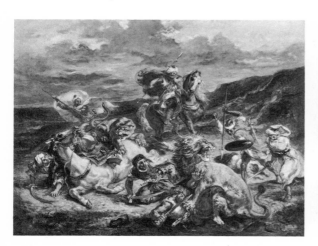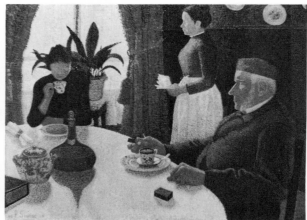

Figure 21. Above left: Eugène Delacroix, THE LION HUNT. (Courtesy of The Art Institute of Chicago.) Above right: Paul Signac, THE DINING ROOM. (Rijksmuseum Kröller-Muller, Otterlo, Holland.) Opposite left: Camille Pissarro, THE BOULEVARDE MONTMARTRE AT NIGHT. (Courtesy of the Trustees, National Gallery, London.) Opposite right: Robert Delaunay, THE RED TOWER. (Courtesy of The Art Institute of Chicago.)

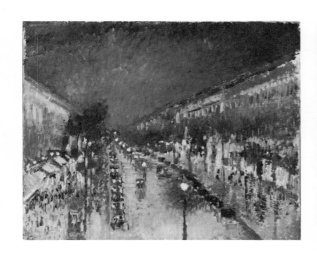

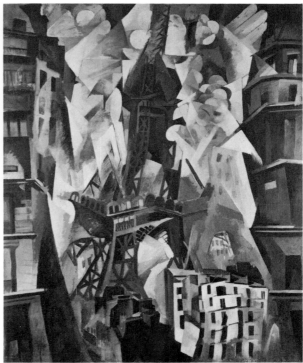

1839 was *De la loi du contraste simultané des couleurs*.) This work was a masterpiece on three counts. (See Figure 20.) First, it presented the first clear statement of the phenomena of simultaneous and successive contrast. Second, and probably for the first time in any book on color, it delved into the laws of visual color mixture, a subject of great importance in the craft of weaving. And third, it set forth — again, probably for the first time — a remarkable series of principles for the harmony of color, principles which ever since have become part of color education throughout the western world. (An English edition of Chevreul's book, edited by Faber Birren, has been published by Reinhold, and beautifully illustrated in color and black and white.)

Before taking up an orderly discussion of color harmony, which is the subject of this chapter, it will be pertinent to offer a few comments on simultaneous and successive contrast, and on visual color mixtures. Chevreul's findings here greatly influenced and inspired the Impressionist and Neo-Impressionist painters of France during the latter part of the nineteenth century. Among his readers and admirers were such men as Eugène Delacroix, Camille Pissarro, Vincent von Gogh, Georges Seurat, Paul Signac, Robert Delaunay. (See Figure 21.) Indeed, the *pointillist* style of painting, in which small dots or swirls of color are used to effect visual mixtures, was more or less founded in theory by Chevreul.

In simultaneous contrast, to quote Chevreul, "If we look simultaneously upon two stripes of different tones of the same color, or upon two stripes of the same tone of different colors placed side by side . . . the eye perceives certain modifications which in the first place influence the intensity of color, and in the second, the optical composition of the two juxtaposed colors respectively."

Many books on color deal with contrast effects and show colored illustrations of them. Such illusions are rather academic today and need little more than cursory attention. However, here are a few examples:

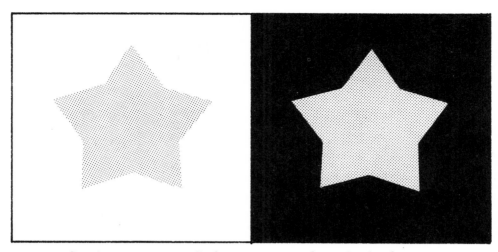

Figure 22. Simultaneous contrast. Both gray stars are identical in brightness.

Figure 23. Simultaneous contrast. Note "fluting" effect where the gray tones touch each other.

In simultaneous contrast of brightness (see Figure 22) light colors will tend to accent the depth of dark colors and dark colors will tend to accent the brightness of light colors. A gray area, for example, will appear relatively dark on a light ground and light on a deep ground.

Where colors of different value are placed side by side (see Figure 23) simultaneous contrast may cause a "fluted" effect. Where the different tones come together edges will tend to be modified in contrary ways.

In simultaneous contrast of color, the effect of the afterimage is quite noticeable. This can be demonstrated with black and white (as in Figure 24) or by staring at a given hue for a short period and then transferring visual attention to another hue to observe reactions.

Contrast effects with hues (both simultaneous and successive contrast) are simple enough to understand. The visual stimulation of any specific hue or color will bring up a reaction to its opposite. (See Figure 19 and Color Plate I.) The afterimage of red is blue-green, and the converse; the afterimage of yellow is violet and the converse; and so forth around the color circle. Opposite colors tend to give brilliance and purity to each other, *and there is no apparent change of hue.*

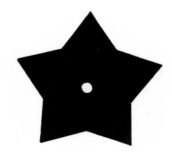

Figure 24. The afterimage. Stare at the center of the black star for several seconds, then look steadily at the small black dot.

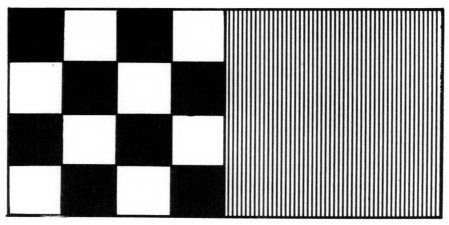

Figure 25. The juxtaposition and diffusion of colors.

However, where the colors are not complementary they affect each other as if their afterimages were tinted dyes or tinted lights. Here are two examples:

With yellow and orange placed side by side (or viewed successively) the violet afterimage of the yellow will tend to swing the apparent hue of the orange toward red, while the blue afterimage of the orange will make the yellow appear greenish.

With red and violet, the green afterimage of the red will make the violet appear bluish, while the yellow afterimage of the violet will swing the red toward vermilion.

Contrast effects in *value* are most noticeable when light and dark colors or tones are employed.

Contrast effects in *hue* are most noticeable when the colors are fairly uniform in value.

As Chevreul noted, a lot depends on area or size of juxtaposed colors. (See Figure 25.) If the areas concerned are large in size, as on the checkerboard

to the left, strong differences in value and hue will cause startling visual effects. Here black and white and complementary hues are most dynamic.

On the other hand, if values or colors of strong difference are presented in minute areas, spots, or lines, and diffused by the eye, they will tend to cancel each other and dullness will result. Red and green *juxtaposed* are vibrant and impulsive. Red and green *diffused* will produce a muddy brown.

In short, opposite colors are best featured in large areas — juxtaposed. Adjacent or analogous colors are well featured in minute areas — diffused.

THE ELEMENTS OF HARMONY

Chevreul founded the art of color harmony when, in his famous 1839 work, he established certain rules and propositions. Individual colors were beautiful in themselves. So were different tones of the same hue. So were different hues (preferably analogous) when seen in uniform or closely related tones. So were different hues (preferably complementary) when seen in strongly contrasting tones. So were assorted colors when viewed as if "through the medium of a feebly colored glass." There were, indeed, "six distinct harmonies of colors, comprised in two kinds."

Harmonies of Analogy

1. "The harmony of scale" in which closely related values of a single hue are exhibited together.

2. "The harmony of hues" in which analogous colors of similar value are exhibited.

3. "The harmony of a dominant colored light" in which an assortment of different hues and values is pervaded as if by a dominant tinted light.

Harmonies of Contrast

4. "The harmony of contrast of scale" in which strongly different values of

a single hue are combined.

5. "The harmony of contrast of hues" in which related colors are exhibited in strongly different values (and strongly different degrees of purity or chroma).

6. "The harmony of contrast of colors" in which "colors belonging to scales very far asunder" are featured. This meant complements, split-complements, triad combinations, and the like.

Today, Chevreul's principles may be summarized as follows and will be given orderly discussion in paragraphs that follow.

1. The harmony of adjacent colors.

2. The harmony of opposite colors.

3. The harmony of split-complements.

4. The harmony of triads.

5. The harmony of a dominant tint.

These refer in general to combinations of pure hues. The harmony of modified colors (tints, shades, tones) will be reviewed in the next chapter. And wholly new types of color effects, based on recent studies of visual phenomena, will be included in a separate chapter on "The New Perception."

THE HARMONY OF ADJACENTS

A number of studies in the field of psychology have verified the observation of Chevreul that colors look best (a) when they are closely related or analogous or (b) when they are complementary or in strong contrast.

Analogous colors have an *emotional* quality, for they favor the warm or cool side of the spectrum when arranged in proper sequence. Opposite or complementary colors have a *visual* quality, for they usually set a warm color against a cool one, thus causing a positive quality to offset a passive one.

Adjacent or analogous colors are those that are next to each other on the color circle. (See Figure 19 and Color Plate I.) Such color schemes or ef-

fects will commonly be found in nature. The rainbow scales from red to orange, yellow, green, blue, violet (purple is missing). The colors of a sunset scale from red to orange, yellow into blue. Autumn colors scale from red through orange, yellow, gold, brown, purple.

Most colors in highlight and shadow will scale through adjacents. A red rose will have orange highlights and purplish shadows. A yellow nasturtium will scale toward orange in the center of the flower to yellow-green at the stem.

As in Figure 26, as colors go brighter, or as illumination on them is increased, there is a general shift toward yellow. As colors go deeper, or as illumination is decreased, there is a general shift toward violet. This seems to be a natural state of affairs and reference to it will be made again later.

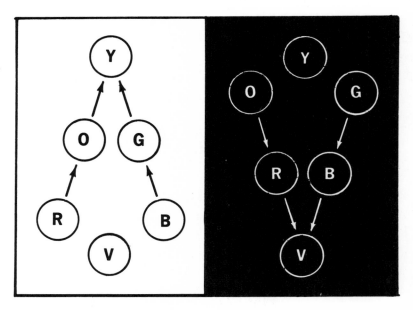

Figure 26. Colors in highlight and bright illumination tend to shift in hue toward yellow. Colors in shadow and dim illumination tend to shift toward violet.

With analogous color schemes, effects are generally best when the key hue is a primary (red, yellow, blue) or a secondary (orange, green, violet). Good color schemes of adjacents are then as follows:

Red with red-violet and red-orange.

Orange with red-orange and yellow-orange.

Yellow with yellow-orange and yellow-green.

Green with yellow-green and blue-green.

Blue with blue-green and blue-violet.

Violet with red-violet and blue-violet.

In all instances the simple primary or secondary is supported and enhanced by two intermediate neighbors that reflect its character and lie on either side of it on the color circle. Most persons will admit, for example, that yellow with yellow-orange and yellow-green looks better than does yellow-orange with yellow and orange, or yellow-green with yellow and green. Reasons perhaps are unnecessary.

In Figures 27 and 28 and in A and B of Color Plate III the adjacents of orange and blue are charted and illustrated. These two colors, one warm like firelight and the other cool like the sky, have been favorites with many artists.

Figure 27. Orange with its adjacents. (Also see A on Color Plate III.)

Figure 28. Blue with its adjacents. (Also see B on Color Plate III.)

The old masters frequently chose an orange flesh tone as a color harmony key, and in Impressionism, blue skies often predominated.

In Plate III note the warm, incandescent quality of color scheme A, and the cool, refreshing quality of color scheme B. This same rich quality, favoring one or the other side of the color circle, will be found with all adjacent color arrangements which have a primary or a secondary as a key hue.

Chevreul liked analogous color effects, but not as much as he did schemes based on opposites. Goethe, the German philosopher and poet, was less liberal. He wrote, "The juxtaposition of yellow and green has always something ordinary, but in a cheerful sense; blue and green, on the other hand, is ordinary in the repulsive sense. Our good forefathers called these last fool's colors."

THE HARMONY OF OPPOSITES

Chevreul wrote, "It almost always happens that true, but exaggerated, coloring is more agreeable than absolute coloring." And again, "The contrast of the most opposite colors is most agreeable. . . . The complementary assortment is superior to every other."

In Figure 29 and in illustration C on Color Plate III, orange and blue complements, or opposites, are shown. Illustration D on Color Plate III illustrates

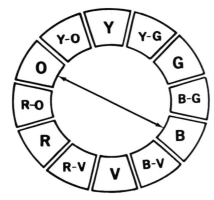

Figure 29. Orange and blue complements. (Also see C on Color Plate III.)

red-violet and yellow-green complements. In both instances there is a lively optical effect. Due to Chevreul's laws of simultaneous contrast, the orange and blue each heighten the intensity of the other, as do the yellow-green and red-violet.

In nature similar color arrangements are to be found. Violet flowers often have yellow centers. Blue on some birds and butterflies is often accompanied by spots of orange. Maxfield Parrish, a famous American illustrator, gained fame by contrasting an effect of orange sunset against a deep liquid blue sky — one of the most pleasing of all color arrangements.

On the color circle (Figure 19 and Color Plate I) opposites are as follows:
Red and green.
Red-orange and blue-green.
Orange and blue.
Yellow-orange and blue-violet.
Yellow and violet.
Yellow-green and red-violet.

Combinations of a primary with a secondary are of simpler and more direct appeal, while combinations of intermediates perhaps have greater elegance and subtlety.

THE HARMONY OF SPLIT-COMPLEMENTS

More advanced contrast is to be effected with the split-complement. Here a key color is combined with the two hues that lie next to its exact opposite. Referring to Figure 19 and Color Plate I, split-complements are as follows:

Red with yellow-green and blue-green.
Red-orange with green and blue.
Orange with blue-green and blue-violet.
Yellow-orange with blue and violet.
Yellow with blue-violet and red-violet.
Yellow-green with violet and red.
Green with red-violet and red-orange.
Blue-green with red and orange.
Blue with red-orange and yellow-orange.
Blue-violet with orange and yellow.
Violet with yellow-orange and yellow-green.
Red-violet with yellow and green.

As with adjacents, the primaries (red, yellow, blue) and secondaries (orange, green, violet) perhaps look better with split-complements than do the

Figure 30. Orange with its split-complements. (Also see A on Color Plate IV.)

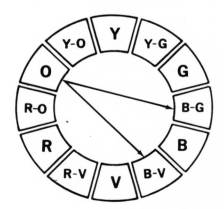

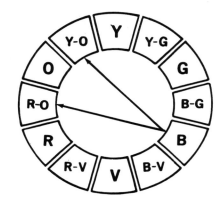

Figure 31. Blue with its split-complements. (Also see B on Color Plate IV.)

intermediates. This, however, may be a matter of personal taste. In Figures 30 and 31 and in A and B on Color Plate IV, orange and blue are charted and illustrated with their split-complements.

There is more variety and beauty with the split-complements than with the direct opposite alone — and therefore more refined color expression.

THE HARMONY OF TRIADS

With the triad color arrangement there is a fuller "diet" of the spectrum, so to speak, but yet with wide latitude as to esthetic and emotional effects. Referring to Figure 19 and Color Plate I, there are four triad possibilities:

The primaries, red, yellow, blue.

The secondaries, orange, green, violet.

Intermediates, red-orange, yellow-green, and blue-violet.

Intermediates, yellow-orange, blue-green, and red-violet.

Each of the above combinations is quite individual and distinct in its impression. The primary triad of red, yellow, blue is primitive, direct, and has a universal and unsophisticated charm.

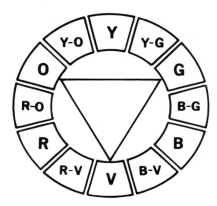

Figure 32. The triad of orange, green, violet. (Also see C on Color Plate IV.)

The secondary triad of orange, green, violet (see Figure 32 and C on Color Plate IV) is more refined.

The combination of red-orange, yellow-green, and blue-violet is the most violent and startling. (See Figure 33 and D on Color Plate IV.)

There is an oriental quality to the combination of yellow-orange, blue-green, and red-violet.

Again, color effects can range from the elemental to the exotic as different balanced "steps" are made about the color circle. There is an opportunity to express that which is out-going and impulsive and that which is more choice and fanciful.

THE HARMONY OF A DOMINANT TINT

The colors of nature (and those fashioned by man) are commonly seen under tinted light that varies from the pink and orange of early dawn, to the yellow of sunlight, to the blue of sky light. Distance may be enveloped in grayish or purplish mist.

Artists have long noted these effects and have endeavored to achieve har-

monies brought about by the influence of an all-pervading hued tint. Many of the canvases of such old masters as Titian have a golden glow — in some cases due to the yellowing of pigments and varnishes. Other painters, like Claude Lorrain, glorified the warm glow of sunset. The American George Innes caught the luminous beauty of Indian summer. Whistler was fascinated by the misty depths of night. (See Figure 34.)

The dominant tint will effectively draw a group of colors together by introducing an all-over mellow tone. The easiest method, and the one used for illustration A on Color Plate V, is to design a composition having a normal series of colors and then wash a transparent tint over it. Tints of yellow and blue have been used in illustration A on Color Plate V. The yellow tint shifts the ground colors toward a warm, sunny harmony, and the blue tint swings the ground colors toward an effect of moonlight. The method is an easy one and almost guarantees a concordant and beautiful result, regardless of how crude the underneath colors may be before they are tinted.

A later chapter, "The New Perception," will describe a more original and compelling approach to luminous and tinted light effects in modern color expression, effects made possible by recent studies in the psychology of seeing.

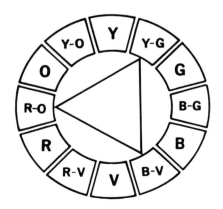

Figure 33. The triad of red-orange, yellow-green, and blue-violet. (Also see D on Color Plate IV.)

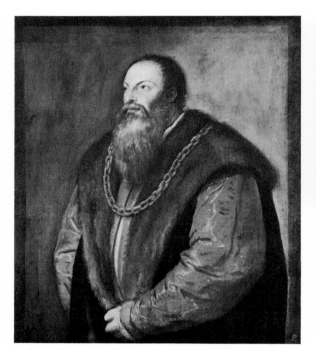

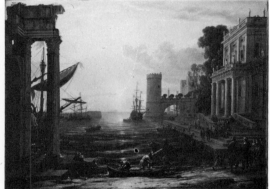

Figure 34. Above left: Titian, PORTRAIT OF PIETRO ARENTINO. (Courtesy Frick Collection, New York.) Above right: Claude Lorrain, EMBARKATION OF THE QUEEN OF SHEBA. (Courtesy of the Trustees, National Gallery, London.) Opposite left: George Innes, THE HOME OF THE HERON. (Courtesy of the Art Institute of Chicago.) Opposite right: James McNeill Whistler, NOCTURNE, SOUTHAMPTON WATERS. (Courtesy of The Art Institute of Chicago.)

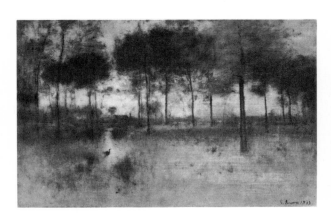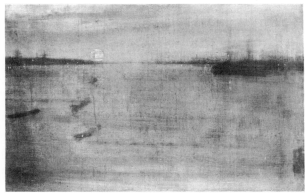

A NATURAL LAW OF HARMONY

To close this chapter, consider the following observation which seems to constitute a natural law of harmony. (Refer to Figure 35 and to illustrations B and C on Color Plate V.) Here is the law:

In combining colors in a design, painting, or composition, hues that are normally light in value — when pure — such as yellow, orange, yellow-orange, green, yellow-green, make the best tints, while hues that are normally dark in tone, such as red, red-violet, violet, blue-violet, blue, make the best shades. (Study Figure 19 and Color Plate I.)

Working out a four-color scale on the warm side of the color circle, a pale yellow, pale orange (peach), deep red (crimson), and deep violet look well

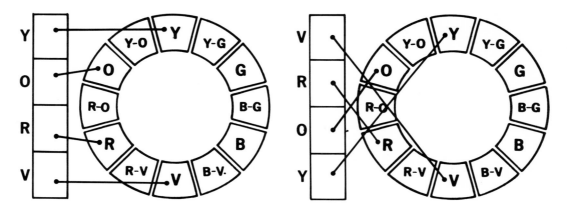

Figure 35. Natural and unnatural color sequences, as described in the text. (Also see B and C on Color Plate V.)

together. The values from light to dark seem to follow a natural sequence. (See B on Color Plate V.)

Yet where the values are reversed (C on Color Plate V) discord follows. The yellow is made a deep olive; orange is made brown; red is made a strong pink; violet is made lavender. Now the sequence, in this order, seems ungainly and unnatural.

To pick a few more examples at random which seem to apply to the above law, a pale green looks better with a deep navy blue than a pale blue looks with deep green or olive. Pale yellow looks better with maroon than pink looks with a deep citron (a shade of yellow). Study of the color circle and of the normal values of pure hues — and their tints and shades — will clarify the law described above.

This leads to "The Harmony of Color Forms" taken up in the next chapter, and to effective principles for the pleasing arrangement of modified colors, tints, shades, tones.

46

The Harmony of Color Forms

Figure 36 and Color Plate II show the color triangle developed by this writer in 1937. Although Goethe had conceived of a triangle over a century and a half ago (see Figure 6) he had used it as a diagram to confine all pure spectral hues. The Scottish scientist James Clerk Maxwell (ca.1865) also devised a color triangle which is still used today by the physicist in the analysis of light. This triangle, with red, green, and blue on its angles, contained the sum total of all pure colors in light and scaled toward a white center. (See Figure 37.)

Around 1878, Ewald Hering, an eminent German physiologist, devoted himself to a study of color and color vision and let the facts of perception — not light rays or pigments — be his exclusive concern. He declared red, yellow, green, and blue to be visual primaries (see Figure 14) and created the triangle shown in Figure 38. He wrote, "If we imagine a clear red of a specific hue placed at one corner *r* of a triangle, a completely pure white at the second corner *w*, and a completely pure black at the third corner *b*, then all possible

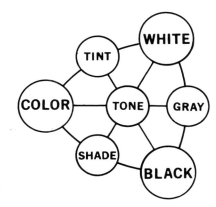

Figure 36. The Color Triangle. (Also see Color Plate II.)

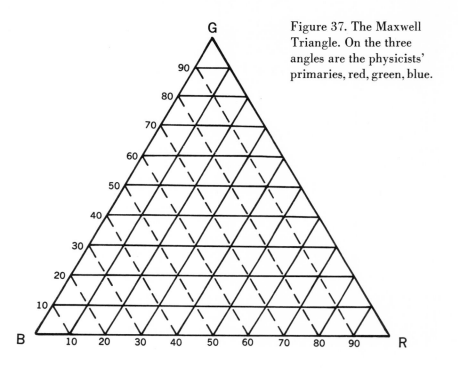

Figure 37. The Maxwell Triangle. On the three angles are the physicists' primaries, red, green, blue.

transitions of red toward white, toward black, or toward gray could be plotted." Incidentally, color scales that ran vertically (ρ to σ) he referred to as being veiled.

The color system of Wilhelm Ostwald was founded on Hering's remarkable triangle, and this triangle represents one of the greatest inventions in the visual and psychological realm of color.

If, as Hering assumes, all possible modifications (visual) of a color can be included within the boundaries of a triangle (having the pure color on one angle, white on the second, and black on the third) then it becomes possible

to take an immensely complex structure — the world of color and color varia-
tions as seen by the eye and interpreted by the mind — and reduce it to the
simple and compact formula of Figure 36.

At this point let the reader appreciate that there is a vast difference between
the world of color as a physical and scientific phenomenon and the world of
color as personally experienced in human sensation. The former is limitless
and infinite, while the latter is of a far simpler order.

There are two different answers to the question "how many colors are
there?" If colors and color variations are to be judged and measured in terms
of wavelengths, luminance, degrees of reflectance, and the like, there are

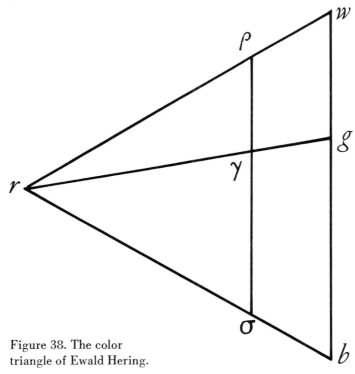

Figure 38. The color
triangle of Ewald Hering.

millions of colors. But if colors are to be judged by the eye and clearly distinguished by the eye, the variation of colors is remarkably limited in number — and probably to not more than a *few thousand*.

In pure spectral light, for example (as seen in a spectrometer or in a beam of light refracted through a prism), a number of studies have obliged scientists to admit that the eye cannot distinguish more than about 180 different hues! Still fewer could be distinguished if a color circle were produced with dyes, inks, or pigments. However, when pure spectral colors are modified by the admixture of white and/or black, new sensations are created. There are "whitish" colors, like pink and lilac, "blackish" colors, like brown and navy, "grayish" colors, like rose and beige.

Yet even here, in the mysterious process of seeing, there is insistence on simplification. Quite emphatically, color vision is not ruled by mere response to stimulation — like a camera or scientific instrument — but by mental response. And such response tends to concern itself, not with finical details, but with larger and more general categories of color.

Looking at a rainbow or a continuous spectrum the eye does not see infinite steps or differences, but wide bands. There are red, yellow, blue, green, and colors that bear resemblance to them, such as orange and violet. Technically considered, the spectrum is composed of innumerable wavelengths and frequencies of light; humanly considered, it exhibits a mere handful of visually different hues.

THE ORDER OF THE COLOR TRIANGLE

Take another good look at the color triangle of Figure 36. If there are relatively few pure or spectral colors in human judgment, so are there relatively few modifications of them. As the color triangle indicates, *visually and psychologically* there is *pure color*, or hues, such as red, orange, yellow, and the like; there is *white*; and there is *black*. These three forms, placed on the angles

of the triangle, are primary and basic. All three are unique in human experience and do not resemble each other in the least!

When the basic forms (pure color, white, black) are combined, four secondary forms are created.

White and black combine to create *gray*.

Color and white combine to create *tint*.

Color and black combine to create *shade*.

Color, white, *and* black combine to create *tone*.

In the psychology of seeing, it is entirely human for the eye (and brain) to survey the vast world of color and to sort what it sees into the seven "boxes" of the color triangle.

Tints like pink and lavender will appear to have both pure color and white in their makeup.

Shades like brown and navy will appear to have pure color and black in their makeup.

Gray will appear to have white and black in its makeup.

Tones like rose and beige will appear to have pure color, white, *and* black (or gray) in their makeup.

It is thus philosophic, if not scientific, to conclude that the human sense of color doesn't want to be bothered with details. In the spectrum of light (see Figure 39) the eye will take innumerable different wavelengths and group them into relatively few bands.

When a pure color is combined with white (or black, or gray), the same simplification will be noted (See Figure 40). For example, in a scale that grades from pure red to white, the sensation of red will persist up to a point when it will suddenly shift to pink. The impression of pink will then persist until all hue has been drained and white is perceived.

Where orange may be scaled down to black (see Figure 40) color impression will "jump" from orange to brown until black is reached.

Figure 39. Although the spectrum contains innumerable wave lengths, the human eye (and brain) will insist on grouping color sensations together in few bands.

Figure 40. In average scales of colors, visual impressions and sensations will tend to fall into simple groups or bands. Transitions will not appear continuous.

To repeat, the eye constantly struggles to see order in color where otherwise there might well be chaos:

It takes countless pure hues and "tracks" them down to a few precise ones such as red, orange, yellow, green, blue, purple.

It takes countless modifications and "drops" them into a few convenient "boxes" such as tint, shade, tone, gray — as on the color triangle.

Why this happy situation exists in human experience perhaps requires no explanation. But it does impress the fact that reaction to color is highly personal and psychological. It bears out the conclusion of Maxwell that "the science of color must . . . be regarded as essentially a mental science."

Two observations are now in order. The fact that it is human to seek simplicity rather than complexity in the world of color is borne out by the paucity of terms used in the description of color. If man were truly interested in fine color differences he would pack his dictionaries with names for them. As it is, there are remarkably few primitive color terms — red, yellow, green, blue, white, black. Most other names are borrowings. Purple comes from the name of a shellfish. Orange, violet, lilac, orchid, rose, on and on, all refer to other things such as flowers. Crimson, vermilion, carmine are taken from words associated with insects and worms. Emerald, ruby, sapphire, turquoise are precious stones. Gold, rust, cobalt, terra cotta are minerals. Cherry, lemon, lime, chocolate, olive, peach are familiar edible products. Salmon, canary, cardinal are fish and birds. Delft, Nile, Sienna, Magenta are places.

As a second observation relating to the known aspects of the color triangle, the eye seems to favor precise form in color and to disfavor anything on borderlines. As cases, if a pure color such as red is slightly diluted with white it may appear faded or "washed out." Yet when enough white is added to create a definite pink, beauty is restored. Orange mixed with a touch of black may appear "dirty," whereas more black will shift the hue to a rich brown.

Figure 41. White, gray, black harmonize.

Whites that are not bright and clean will appear dingy — like newsprint paper. Blacks that are not deep will appear old and weathered.

THE BEAUTY OF RIGHT SEQUENCE

The straight-line sequences of the color triangle (Figure 36 and Color Plate II) are all natural and concordant. Follow any path and harmony results. Such harmony is perhaps agreeable for the simple reason that related visual elements are involved. Tints harmonize with pure color and white because they contain both. Shades harmonize with pure color and black for a similar reason. In diagonal directions, tone becomes the coordinating or integrating form. In the combinations of tint, tone, black, the three primary elements which are contained in tone (color, white, black) naturally tie any such arrangement together. So also is this true of the combination of shade, tone, white.

WHITE, GRAY, BLACK

There is harmony in white, gray, black. To take up the sequences of the color triangle consider first the harmony of white, gray, black. (See Figure 41.)

Although all three forms are unique to the eye, they bear a natural relationship to each other and are wholly without resemblance to pure color or hue.

Most color theorists have reached the conclusion that beauty is the natural product of good order. In Figure 42 white, black, and a medium gray are arranged in four different ways. In the two examples of A, the order is straight, from white to gray to black, and from black to gray to white. The average person will consider these sequences better than those shown in the two examples of B. Here gray moves to black and then white, and black moves to white and then gray.

Figure 42. The visual sequences in A are regular. Those in B are irregular.

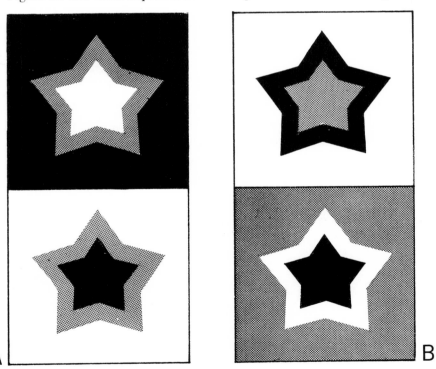

A
B

Sequences and values can, of course, be put together as an artist or designer wishes. Sometimes obvious discord may be wanted. Yet for simple, direct appeal, the 1-2-3 or 3-2-1 order of sequence is preassured of success.

Value sequences also should regard what might be called stability in a design. Because of the apparent "weight" of colors, black seems "heavy," while white seems "light." In A of Figure 43 there is good *architectural* order, with weight at the bottom and working *up* to gray and white. In B there is good *typographical* order, with attention put at the top and the sequence working *down* to gray and white. In C and D there is no apparent order, and for this reason the sequences may appear haphazard.

Figure 43. Studies in visual order for white, gray, black.

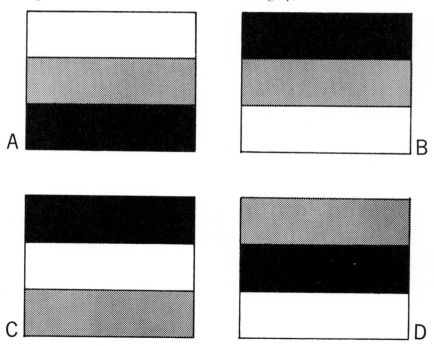

Figure 44. Pure color, tint, white harmonize. (Also see A on Color Plate VI.)

PURE COLOR, TINT, WHITE

There is harmony in pure color, tint, white. (See Figure 44.) The simplest and perhaps most charming sequence on the color triangle is that of pure color, tint, white. This arrangement is found more often than any other — in man-made designs and patterns, and in nature-made flowers. The combination of pure color, tint, white is shown in illustration A on Color Plate VI. (Here and in all the illustrations of Color Plate VI the triad of orange, green, and violet has been used, but in different forms and different sequences.)

The painting schools of Impressionism and Neo-Impressionism were devoted almost entirely to the combination of pure color, tint, white. (Some artists, such as Renoir, occasionally added black for accent.) Previously, most artists had employed ochers, browns, somber shades of green, maroon, blue. The Impressionists and Neo-Impressionists glorified the phenomena of light and used spots of color in an attempt to achieve luminous visual mixtures. Many confined their palettes to spectral hues and avoided black and brown entirely. (See example of Monet in Figure 45.)

It is next to impossible to find discord in any combination of pure colors

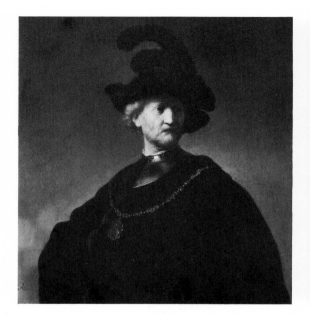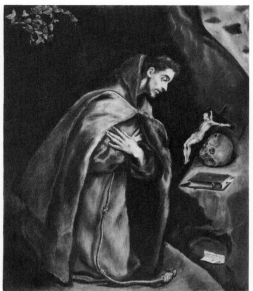

with tints and white. All will seem clean and fresh. Adjacents may be chosen, or complements, split-complements, or triads as discussed in the previous chapter. It is best to use the warmer colors or tints for the feature elements in a composition and to let the receding elements be cool in hue.

PURE COLOR, SHADE, BLACK

There is harmony in pure color, shade, black. (Refer to Figure 46 and to illustration B on Color Plate VI.) Here there is depth and richness of color, with no white and no pastels. If the small areas or details in a composition are kept warm (yellow, orange, red) and if the large areas are cool (green, blue, violet) highly intense and luminous color effects can be gained.

Many of the great masters such as Rembrandt worked with pure color,

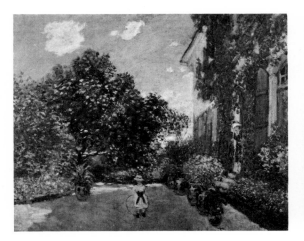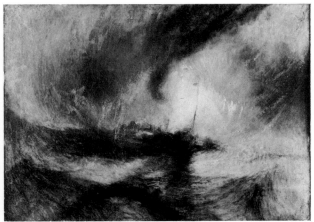

Figure 45. Above left: Claude Monet, Artist's Garden at Argenteuil. (Courtesy of The Art Institute of Chicago.) Above right: J. M. W. Turner, Snow Storm - Steamer. (Courtesy of the Trustees, National Gallery, London.) Opposite left: Rembrandt, Portrait of Harmen Gerritsz. (Courtesy of The Art Institute of Chicago.) Opposite right: El Greco, St. Francis. (Courtesy of The Art Institute of Chicago.)

shade, and black. (See Figure 45.) White or pale gold accents were at times introduced in highlights. Practically all American portrait painting of the late eighteenth and early nineteenth centuries had the pure color, shade, black sequence. Even landscapes were treated this way and were justifiably labeled as brown-gray art. If such arrangements may be suitable for portraits, for certain rugs and textiles, they hardly echo nature. Pure color, shade, black are indoor colors, so to speak, meant for studio painting, for effects of candlelight and firelight. Yet they have great power and force and are fairly easy to put together with little danger of conflict.

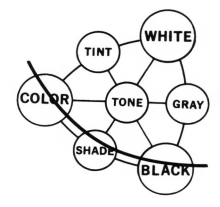

Figure 46. Pure color, shade, black harmonize. (Also see B on Color Plate VI.)

TINT, TONE, SHADE

There is harmony in tint, tone, shade. (Refer to Figure 47 and to illustration C on Color Plate VI.) There is little doubt but that this is the most refined, subtle, and eloquent sequence on the color triangle. It identifies the famous *chiaroscuro* style of painting invented by Leonardo da Vinci and adopted by eminent artists during the Renaissance and after — up to the time of Impressionism. Ewald Hering spoke of this sequence as being *veiled;* Wilhelm Ostwald wrote of the *shadow series.* Consider the following points:

Tint scales can be fashioned by adding white to pure color. Shade scales can be fashioned by adding black to pure color. However, true highlights (not reflections) on a color do not necessarily shift toward white, and true shadows on a color do not necessarily shift toward black.

Da Vinci discovered this in his *chiaroscuro* style and revolutionized the art of painting. The truth of the matter is that as a color goes into highlight it appears purer (not whiter). As it goes into shadow it appears richer and more somber (not merely blacker). How is this "shading" accomplished?

Tint, tone, shade scales have an element in common: while the amount of

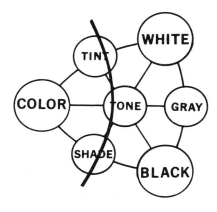

Figure 47. Tint, tone, shade harmonize. (Also see C on Color Plate VI.)

white and black will vary as the scale goes up or down, *the amount of color will seem to remain the same.* The highlight of a lush pink or flesh *tone* will have a "chalky" look if white alone is added to it. Natural appearance will be maintained if some black in the tone is withdrawn and some hue added along with the white. The shadow of a flesh tone will require that some white be withdrawn and some color added along with the black.

This will probably be somewhat confusing. If so, the following notes may help to clear things up. Assume the existence of a tan flesh *tone* containing red-orange, some white, and a touch of black. In a true veiled, or shadow, series, a lighter flesh *tint* would require a mixture of red-orange and white *and no black*, and a deeper flesh *shade* would require a mixture of red-orange and black *and no white*. Clearly, a scale like this would need patience and care in its formulation.

Refer to Color Plate II and study the pink scale of 25-0, 16-30, 10-50, 5-65, and 0-75. This is a true shadow series and *chiaroscuro* scale. To duplicate it would necessitate the mixing of a clean pink (with no black) and a rich shade (with no white). These two would then be intermixed to create inter-

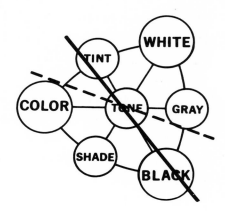

Figure 48. Tint, tone, black (or gray) harmonize. (Also see D on Color Plate VI.)

mediate tones. However, touches of pure red (pink) may be required as the scale approaches a mid point (10-50 on Color Plate II).

The shadow series of a pure hue such as intense vermilion is not readily made. A highlight would have to be restricted to an orange hue and the shadow to a deep maroon. Yet much can be *implied* if attention is paid to what is known as the law of field size and if areas of pure hue are employed and visually dramatized within a generally dark field or ground.

TINT, TONE, BLACK

There is harmony in tint, tone, black. (Refer to Figure 48 and to illustration D on Color Plate VI.) The world of color rests on a three-legged stool of pure hue (any and all), white, and black. The opposite or antithesis of pure hue is not white or black, but gray. As a means of contrast, gray has been but little recognized by artists of the past. The one exception has been J. M. W. Turner of England, one of the greatest colorists of all time. (See Figure 45.) Turner was fascinated by light phenomena, by sunrises and sunsets, and one of his idols was Claude Lorrain of France (see Figure 34) who died nearly a century before Turner was born. Turner anticipated Impressionism and

much of the art of modern times. It was he who made — and demonstrated — the remarkable discovery that colors could be made to appear astonishingly luminous, not by contrasting them with black and deep shade, but with grays and softly hued tones.

The combination of tint, tone, black, or tint, tone, gray, as plotted in Figure 48 leads to surprisingly luminous effects. *In this arrangement or principle the lighter value is pure and the deeper value grayish* — and brightness difference is moderate rather than excessive. Scales and color compositions from tint to tone to black or gray are easily mixed. One has merely to begin with one (or more) fairly strong tints and then mix them into a scale with a neutral gray that is somewhat deeper in value.

With so simple a procedure, color harmonies that have the quality of shimmering lights or mother-of-pearl are possible. Here again a new principle is revealed which will be touched upon in the last chapter of this book. Compositions may be arranged involving adjacent colors, opposites, split-complements, triads. The warm colors, as pure as possible, should be used as the luminous features, with the cool colors used for the ground and kept slightly deeper and grayish in tone.

SHADE, TONE, WHITE

There is harmony in shade, tone, white. (Refer to Figure 49 and to illustration E on Color Plate VI.) *In this arrangement or principle the deeper value is pure and the lighter value grayish* — precisely the contrary of tint, tone, black (or gray). Effects here are quite unnatural and lead to arrangements that are unconventional and unfamiliar.

By intuition, perhaps, the Spanish painter El Greco used such sequences. (See Figure 45.) In most of his compositions he featured deep rich shades of gold, green, blue, crimson, and worked them up toward a chalky and eerie

Figure 49. Shade, tone, white harmonize. (Also see E on Color Plate VI.)

white. His figures, religious for the most part, were elongated and his color effects "not of this world."

While combinations of shade, tone, white have their peculiar attraction, not many persons will consider them pleasing. They tend to be "dry" and "dusty" in impression and to run contrary to the average psychological preference for that which (a) is intense in color, or that which (b) is clean and fresh.

PURE COLOR, WHITE, BLACK
TINT, SHADE, TONE, GRAY

The three primary forms of color are pure hue, white, black. (See Figure 50.) All three go well together and are perhaps most dynamically expressed where the hues employed are also simple, such as red, yellow, blue, orange, green, violet. These can be combined in accordance with the principles set forth in the previous chapter on "The Harmony of Colors."

The secondary forms, tint, shade, tone, gray, also blend concordantly and are more refined and restrained. With them, and to hold to a tasteful spirit,

it may be well to plan arrangements of the intermediate hues red-orange, yellow-orange, yellow-green, blue-green, blue-violet, red-violet.

Finally, appreciate that the most neutral of all forms is tone, not gray. The point has already been made that the antithesis of pure color is gray, for gray contains the two primary elements (white and black) that are lacking in hue. Brilliant vermilion, for example, may clash with gray and appear garish.

Perhaps the most neutral of all colors would be a tone of red-violet which blends the two extreme ends of the spectrum, red and violet. It will be found passive and retiring in nature, neither warm nor cool, neither active nor passive, and it suggests the nearest thing to the soft, mellow atmosphere of far distance — against which virtually all other colors seem to appear enhanced.

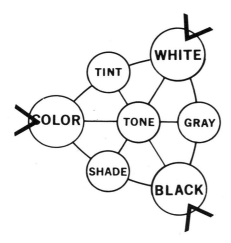

Figure 50. Pure color, white, black harmonize.

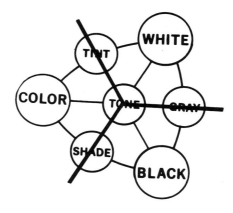

Figure 51. Tint, shade, tone, gray harmonize.

The New Perception

In this writer's book *History of Color in Painting* the following statement is made. "Beauty (or ugliness) is not out *there* in man's environment, but *here* within man's brain. Where formerly some artists strove to find laws in nature, now one may be sure that such laws, if they exist at all, lie within the psyche of man.

"The perception of color — including feeling and emotion — is the property of human consciousness. If man is awed by what he sees in his surroundings, he should be far more impressed by what lies within the sanctuary of his own being. This is where to look, not in ignorance but in sensitive understanding."

So far the present book has dealt first with "The Harmony of Colors" in which the principles of M. E. Chevreul were set forth as conceived by him during the middle of the nineteenth century, and second with "The Harmony of Color Forms" in which this writer has derived still further principles relating to the concordant arrangement of modified colors, tints, shades, tones.

As the art of color progresses, new directions and incentives for expression are being drawn from research in the fields of vision and the mysteries of human perception. A great fund of unique and remarkable findings has made possible still a third set of principles which are yet to be fully exploited by the artist and designer and which should lead to color harmonies that strike out into the future and have little precedent.

Color is individual to human experience and sensation. And the strange ways in which man sees color promises a fresh and highly personal art of tomorrow. There is one notable fact to be appreciated, namely, that perception and visual reaction to color are remarkably independent of what takes place in the outer world by way of stimulation. For example, color will be

seen if pressure is applied to the eyeball. Here no external light energy is at all involved. In a phenomenon known as color constancy, the human eye (and brain) will persist in seeing colors as normal, despite radically different external conditions. As a case in point, a square of white paper or a white handkerchief will appear *white* whether seen in broad daylight or in the dimness of a cellar. Thus it cannot be said that white sensations require high intensity of stimulation and black sensations low intensity, for this is not true.

MODES OF APPEARANCE

Nature produces color in many ways, by dyes and pigments, by refraction and diffraction (the rainbow, iridescence), by scattering (the blue sky), polarization, and other methods. Although the *physical* nature of such colors may differ radically, the *sensations* they produce in vision may be more or less alike.

A color such as red can have a wide variety of modes of appearance: it can be solid and opaque like an apple; filmy and atmospheric like a sunset; three-dimensional like a goblet of wine; transparent like cellophane; luminous like a traffic light; dull like suede or lustrous like silk; metallic like a Christmas tree ornament; iridescent like the gleam of an opal. While these several reds might well be the same in a *physical* sense, they would have quite different *visual and psychological* aspects.

In the New Perception the color *effect* becomes vital, as distinct from the traditional color *scheme*. Red as red may have a certain beauty and emotional quality, but red can have many singular modes of appearance — and here the artist and designer can traverse and conquer new territory in the world of color.

He can, as well, free himself quite effectively from the limitations of his mediums. He will create visual impressions, the elements of which are in the eye and brain, whether he uses paints, dyes, yarns, ceramics, or such.

Now consider five color effects or visual principles. These relate to the wonders of human perception — your eyes and mine — and they lead to new dimensions of color expression.

THE EFFECT OF LUSTER

Two things are important to the sense of seeing. One is apparent illumination. The other is the general distribution of brightness (and darkness) and of hue in the field of view.

To explain, look at Figure 52. Here a white star and a black star are shown on a gray ground. Normal illumination is implied, and the effect seems quite

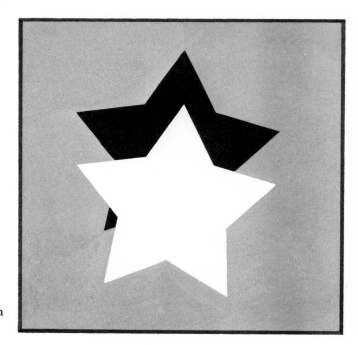

Figure 52. An impression of normal illumination.

ordinary and natural. The eye needs good illumination to perceive black and white. Thus if both are displayed together, the experience is a familiar one.

However, when illumination quality is changed, when the elements in the field of view are expertly manipulated, the eye can be inspired to see unique effects. Control by the artist leads to surprising interpretations, and what is perceived may more or less contradict the "facts" of the design or composition.

Different modes of appearance for color are readily achieved where the artist understands the makeup of perception and designs color effects that stimulate intended reactions. In Figure 53, an effect of luster is attempted. (Also see illustration A on Color Plate VII.)

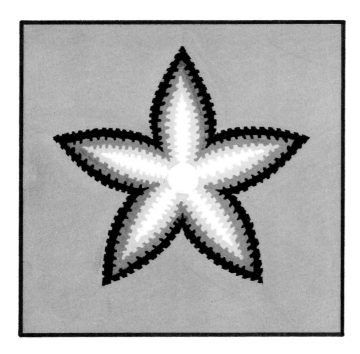

Figure 53. An impression of luster.

In perception, a lustrous color, as distinct from an ordinary color, appears to be brighter than bright, so to speak. Although a piece of silk and a piece of cotton may reflect the same intensity of light, the one will be lustrous and and the other will not. Yet the effect of luster can be easily simulated.

The "trick" is to create an overall impression of subdued light. In Figure 53, the background is dark gray. Now with the highlight of the star a clean white, and with this white shading into deep black, the white area seems to glisten. In illustration A on Color Plate VII the same simple device has been used to make yellow, red, and blue appear lustrous. It is important merely to keep the lustrous areas relatively small in size and pure in hue (or whiteness), to suppress the ground, *and to rely on black* contrast.

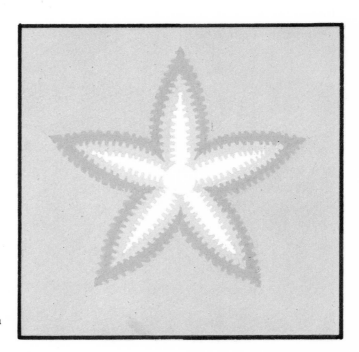

Figure 54. An impression of iridescence.

THE IRIDESCENT EFFECT

Figure 54 and illustration B on Color Plate VII portray the iridescent effect. In nature, iridescence such as in an opal or mother-of-pearl, or in butterfly wings, is not due to pigments or dyes but to diffraction brought about by minute structures or "screens" in the material which take the rays of light and split them up into their component hues. Iridescence also tends to shift and "shimmer" when seen from different angles — a phenomenon that requires skill to reproduce in a static drawing or design.

Whereas luster demands black contrast, *iridescence requires gray contrast.* In Figure 54 it will be noted that the background to the star is a light gray. The highlights on the star are white, and the shading is in a gray that is slightly *deeper* than the ground. The effect, even in black and white, is successfully done.

Where color is introduced, as in illustration B on Color Plate VII, note that the tints of yellow, pink, and blue are pure, that the shading goes into gray tones, and that the background is a light, neutral gray. Where these devices are properly — and easily — coordinated, an iridescent beauty follows. Perception is forced to take action. The eye and the brain put into the design a quality which really does not exist externally but in the visual response of the beholder. Any medium can be used — tempera or poster colors, oil or acrylic paints, threads or yarns, plastics, ceramics, pile materials such as carpeting. Iridescence is achieved, not literally with shiny things but visually and psychologically through the magic and curious makeup of the sense of sight.

THE LUMINOUS EFFECT

Luster, iridescence, and luminosity are all related as visual phenomena. To duplicate them many artists of the past have resorted to mechanical devices,

the use of metal foils, transparent glazes over metal or glass, actual gems and semi-precious stones. With an understanding of perception, today far more striking effects are to be gained as visual illusions.

While it is true that a number of artists have been able to create luminous effects, this was accomplished mainly through intuition, trial and error — and genius. The paintings of Titian, Rembrandt, Georges de la Tour often show light sources and brilliant lighting effects. The sunsets of Turner are likewise quite convincing and dramatic. However, the Impressionists and Neo-Impressionists, who used a pointillist technique of small dots and who sought to mix colors optically for extreme luminosity, failed for the most part in their endeavors. Brilliance of color is better achieved in other ways.

Refer to Figure 55 and to illustration C on Color Plate VII. Luster de-

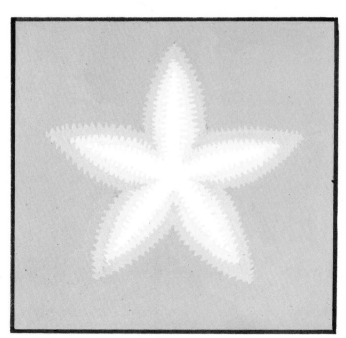

Figure 55. An impression of luminosity.

mands black contrast; iridescence demands gray contrast. For luminosity a good deal of subtlety is necessary. Here are the "rules":

The area or areas to be luminous must be relatively small in size so that the major field or ground can be used to establish an effective setting.

The luminous area or areas must be higher in value or brightness than anything else in the composition.

They must also be the purest colors in sight and have the strongest chroma.

The apparent light sources must seem to pervade the entire painting or design and influence it accordingly.

Deep values and dark colors must be avoided.

While it has been conventional in color training to assume that maximum contrast is found in opposite hues and in high degrees of value contrast, both of these will destroy any hope of a luminous effect. To attempt to portray a red traffic light, for example, by outlining it with black and surrounding it with a deep rich green will turn the light off and make it appear as if in natural daylight. First of all, darkness is not black but a deep atmospheric gray. Secondly, if a red light were to shine forth, it would create halation in the eye and would cancel or neutralize any opposite hue such as green or blue-green. Despite the external physical facts of luminosity, in human perception contrast must be moderate rather than extreme.

In Figure 55, the highlights of the star are white and the shading is soft. The entire star is lighter in value than the ground, while the difference in brightness for all values is slight. In illustration C on Color Plate VII the same principles are applied with color. The clear tints of yellow, pink, blue, mixing their luminosity together, shine forth in a muted blue atmosphere.

THE EFFECT OF TRANSPARENCY

Figure 56 and illustration D on Color Plate VII show effects of transparency. The original drawings, however, were executed with opaque watercolor. Where

Figure 56. An impression
of transparency.

one transparent color, such as an ink or dye, is sprayed or coated over another color, the result is not the same as if the eye looked through overlapping pieces of tinted cellophane or glass. Paint mixtures are not the same as light mixtures; the human eye will be quick to notice the difference.

To make transparent effects wholly convincing, it is best and proper to observe what happens when the eye looks through overlapping transparent substances *and to match what is thus seen with paints or other mediums*. Where opaque materials are employed to simulate transparent effects, results are often intriguing — and new and higher forms of expression are attained.

EFFECTS OF CHROMATIC LIGHT

The illustrations on Color Plate VIII show four different effects of chromatic light. The harmony of a dominant tint has been discussed in a previous chapter and illustrated in A on Color Plate V. Effects of colored light are eternally pleasing to the human eye, for light is pure and celestial in its quality. Where this charm is accomplished with the ordinary materials of the artist, beauty is well served.

It will be noted that the effects on Color Plate VIII are more intriguing than those in A on Color Plate V. As has been said, light mixtures are not the same as pigment or dye mixtures, and to achieve truly advanced color expression it is well to understand this difference.

Nature makes a spectacle of chromatic light in the pink and orange of sunset, the golden glow of Indian summer, the purple mist that clings to a distant mountain, the blue of the night, and the eerie gray that so often precedes a storm. She drenches the atmosphere with these tints, and artists for centuries have tried to duplicate them on canvas.

Yet man can do even more (if not better) by conquering the perceptual mysteries of chromatic light and then creating new effects which nature has not bothered to exhibit.

How about chromatic light effects in yellow-green, blue-green, blue, orchid, lilac — or anything the heart desires? And such effects can be realistic, imaginative, or completely abstract.

In developing palettes for chromatic light effects the following procedure is recommended. Remember that lights and pigments react differently. Yellow and blue pigments will produce a fairly pure green, while a yellow light shining on a blue surface (or the converse) will tend to produce a deep blackish olive.

First, set up a color chart having a selection of opaque pure hues, tints, and

a few tones. Study the effect of colored light on this chart — or preferably look at it through tinted cellophane or theatrical gelatin of any desired hue and tint.

Then match what is seen in paints (or yarns, plastics, ceramics) and proceed with a painting or design.

The four illustrations on Color Plate VIII hint of what is to be accomplished. Work with any harmonious arrangement of colors and color forms. There will be little danger of discord, however, for the influence of the chromatic light will in itself act like a harmonizing agent.

If the reader is truly ambitious he may try his best to combine the beauty of chromatic light with accompanying effects of luster, iridescence, luminosity, transparency, all at the same time!

A FEW PRACTICAL NOTES

To end this chapter, here are a number of significant facts about color, all drawn from the experience of the writer over many years. Knowledge of them should enable the artist and designer to use color with sophistication and skill.

Colorists such as Albert H. Munsell have pointed out the desirability of paying attention to color purity or chroma in arranging color schemes. Warm and bright colors for the most part look best in *small* areas set against *large* areas of cool color. Such practice is good to follow.

Further than this, colors have dimension. The eye actually becomes farsighted in its focus when it sees red, and nearsighted when it sees blue. Therefore warm colors such as red, orange, yellow will appear near, while cool colors such as green, blue, violet will appear more distant. The lesson to be learned here is that warm areas or touches in a design or composition should be placed to appear *in front* of cool areas.

As to dimension, it is also true that pure color, white, and deep black all suggest nearness to the eye. In aerial perspective there is a tendency for all

colors to blend into a light gray (with a violet tinge) as they fall back into distance. White will soften a trifle. Black will climb up to a medium gray. Pure hues will shift to pale tints and tones. These effects will be seen in nature.

Colors also have apparent size. The visual image of any light or pale color will tend to expand like a drop of water on blotting paper. Deeper colors will tend to contract. Thus yellow will be seen as the largest of colors, followed by white, red, green, blue, black. Pastels will appear larger than shades.

In visibility, yellow holds advantage over other colors. It is the brightest hue in the spectrum, is sharply focused by the eye, and is free of aberration (blur). Next would be a brilliant orange which is commonly used in air-sea rescue work. Then would be a vermilion red, and then an intense yellow-green.

In attention-value, important in such things as packages and posters, red-orange ranks first, followed by vermilion, then yellow, yellow-green, and a cerise pink. However, in color recognition (and memory), red is the easiest color to recognize and identify. Next is green, then yellow, then white.

Due to the phenomenon of the afterimage, the most flattering of all colors is a blue-green (see Color Plate I). Where it is used as a background, its warm pinkish afterimage will cast a pleasing glow over average human complexion, regardless of race. It is the color used in hospital surgeries and operating rooms because it complements the tint of human blood and tissue and thus offers relief from eye fatigue to the surgeon.

Finally, in a psychological way, red-orange and vermilion red are "hot" while blue and blue-violet are "cool." Good "smelling" colors are pink, lilac, orchid, cool green, aqua blue. Good "tasting" colors are vermilion, orange, warm yellow, pale cool green, tan — not purple, yellow-green, gray. Red colors are "loud" like the blare of a trumpet. Violin tones are like tints. The sound of the oboe is violet. Bass notes are brown, percussion notes are orange.

All of color is thus human and seems to relate to all of life and all of sensation and experience in life.

THE NEW ENVIRONMENT

Any artist, designer, or student should appreciate that the world at large is undergoing many changes. One of these concerns environment, and the point that man lives more and more in space — space beyond the earth and space within man-made structures. Art in frames and art on pedestals is giving way to art that is more a part of life. There is now sculpture on the grand scale. There is painting and decoration that envelops space. There is an art of mobile color, Lumia, dramatic and emotional effects with color that involve the manipulation of lights, shadows, flowing abstract forms.

Such expression becomes environmental for the simple reason that a great deal of it demands human participation. There is art into which people walk and communicate with each other. There are color and light demonstrations that relate to sounds, that seek to exert strong emotional impact — not unlike that which follows the taking of psychedelic drugs.

So it is that the artist and designer are taking a greater role in life itself. They are becoming psychologists and sociologists (in part, at least) in that old reclusive habits are being broken for more direct action among and with people. Color is everywhere being given more dynamic use and broader distribution in virtually all quarters of life.

All of which, of course, opens up new avenues of opportunity for color and for those who have true facility with it.

References

To those who wish to pursue the study of color to further lengths, four other books by Faber Birren are recommended. All are available from the Van Nostrand Reinhold Company of New York.

Creative Color, first of all, will be found to elaborate upon the principles given in this present work. It is richly illustrated in full color and comes highly recommended for basic training in color theory and harmony. The book has two parts, the first of which is devoted to such subjects as color terms, color scales, color organization and mixture, traditional color harmony. The second part takes up those new concepts of color which deal with research in human perception — an original approach for which Faber Birren has won wide fame and attention. Each chapter ends with a suggested series of experiments so that the reader can undertake a practical training course on his own. *Creative Color* is a standard text in many schools and has become quite a classic in the field of color education.

The second work, *History of Color in Painting*, is an elaborate one. It is a large book, 9 x 12 inches, 372 pages, 100,000 words of text, 32 full-color plates, 500 black-and-white illustrations, and took Mr. Birren more than a few years to put together. A unique work, it traces the course of color expression in art since the time of the Renaissance. Special attention is paid to the color expression of great painters, to the palettes they used, and to the theories of modern art movements. There are two parts, the practical methods of the artist and the historical references which present a chronological story of the art of color in painting.

The third work is that of M. E. Chevreul, *The Principles of Harmony and Contrast of Colors*. The importance of Chevreul's theories of color has been reviewed in fair detail here in the chapter on "The Harmony of Colors."

Faber Birren has contributed notes on Chevreul's life, the value of his conclusions, and his influence in the world of art. In addition, there are some 25,000 words of marginal comment to accompany the reprint of the original English text. The book is large in size, 12⅜" x 11⅜", 256 pages, 68 tipped plates including 28 in color. This is truly one of the great books in the literature of color harmony and should be on the shelf of every library, studio, or home as an essential reference source in the field of art and color.

The fourth work, *Color and Environment,* while addressed primarily to architects and interior designers, will have much interest and value to artists who feel concerned with the beauty and appearance of man-made surroundings. This would include offices, schools, hospitals, stores, motels and hotels, restaurants, mass housing — as well as homes. Such spaces as these need creative talent just as much as do museums and art galleries. The book is large in size, 9 x 12, and is generously illustrated. Included in the text are authoritative notes on the biological and psychological effects of color, as well as data on period styles and a review of the history of color in architecture.

COLOR PLATE I

As the first chapter of this book makes clear, color circles can be of various designs and arrangements. The one shown on Color Plate I, following page, and in Figure 19, page 27, is that of the artist and follows the tradition of the artist. Its primaries are a slightly purplish red, a clear yellow, and a spectral blue. The secondaries are orange, green, and violet. This color circle, however, also shows complements (red-green, yellow-violet, blue-orange, etc.) which are fair visual opposites. Whether yellow finds its true complement in ultramarine blue (Ostwald), in purple-blue (Munsell), or as on Color Plate I is of no great consequence. In color harmony, generalities alone are important. The eye seems to take delight in color schemes based on the strong opposition of hue (this is one of several principles) and almost any pair of colors that stand in marked contrast with each other will be pleasing.

Favoring the artist, it will be noted that the color circle of Plate I has a fairly equal distribution of warm and cool colors and is not extended in the cool region. (See discussion in text regarding Figure 17, page 24.) Thus this circle serves as an excellent chart or tool on which to plot harmonious color combinations. It is essential in color training and education and becomes a starting point from which beauty can be made to flow.

COLOR PLATE I

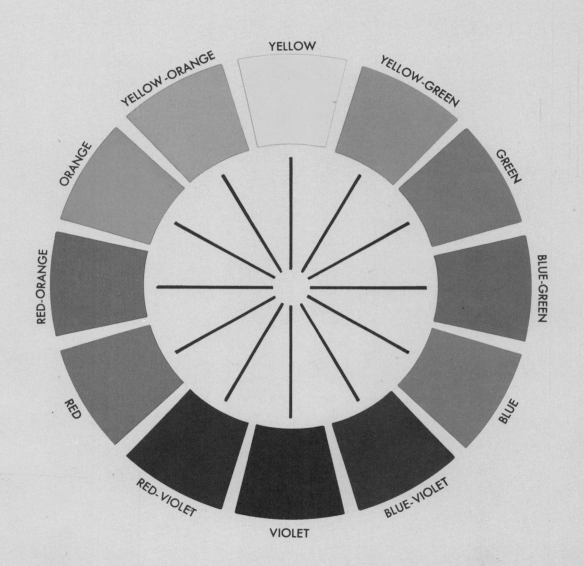

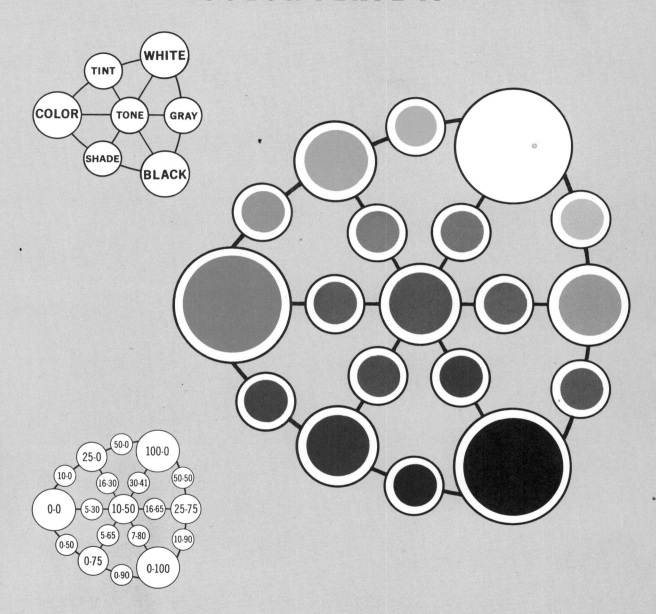

COLOR PLATE II

The color triangle shown on Color Plate II, preceding page, is a simple but remarkable diagram of visual and psychological color relationships. (Also see Figure 36 on page 47 and its accompanying text.) It is individual to human experience and sensation to see the world of color in terms of a few basic forms. As in the upper left triangle of Color Plate II, there are pure colors (any and all, such as red, yellow, blue); there is white; and there is black — and all three differ. Pure color and white combine to form tint; pure color and black combine to form shade; and pure color, white, *and* black combine to form tone. All color variations and modifications will be classified as one of these seven forms.

In the lower left triangle, formulas are given for the development of color scales that follow straight paths on the triangle. The first numeral in each formula refers to white content and the second numeral to black content. Hue content is the sum left over to equal 100. The formulas are set up and spun on a motorized wheel and the resultant visual mixture matched with paints. Thus, 0-0 signifies a pure hue; 25-0 a clean tint having no black in it; 0-75 a rich shade having no white in it; and 10-50 a tone having 10% white, 50% black (and 40% pure color).

COLOR PLATE III

The color schemes on Color Plate III, following page, combine pure hues in accordance with traditional laws of color harmony. In illustration A is an arrangement of orange with its adjacents red-orange and yellow-orange. In illustration B is an arrangement of blue with its adjacents blue-green and blue-violet. Where adjacent or analogous colors are brought together, one or the other side of the color circle is favored. Hence, adjacent combinations usually have a strong emotional quality in that they will be predominantly warm or cool. It is perhaps best to key adjacent combinations on primaries (red, yellow, blue) or on secondaries (orange, green, violet), letting the intermediate colors support them. For example, yellow perhaps looks better with yellow-orange and yellow-green than the intermediate colors will look with their adjacents.

In illustrations C and D complementary pairs are shown which contrast orange with blue, and yellow-green with red-violet. Here the effect is visually startling and involves maximum opposition of hues. Also due to simultaneous contrast and the influence of afterimages, complements tend to enliven each other and to add apparent chroma or saturation to the vividness of the colors.

COLOR PLATE III

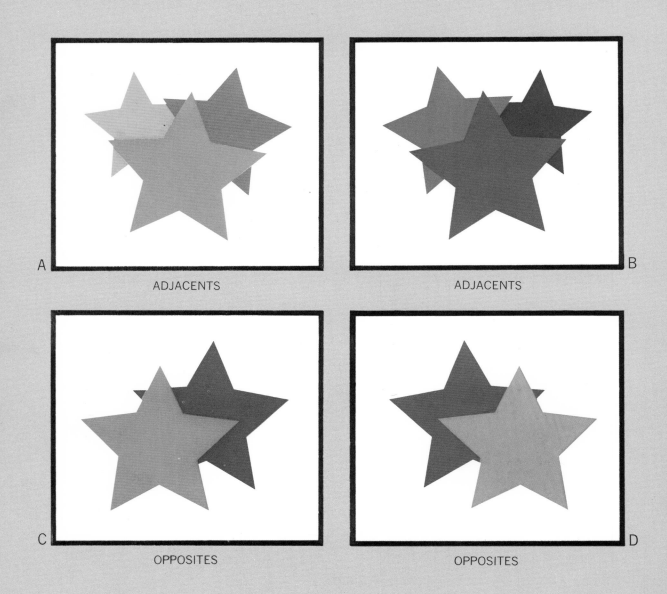

A ADJACENTS

B ADJACENTS

C OPPOSITES

D OPPOSITES

COLOR PLATE IV

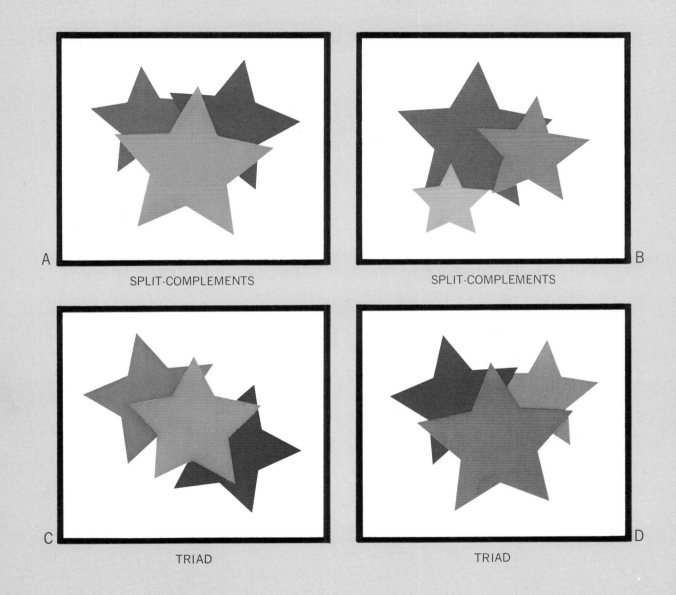

SPLIT-COMPLEMENTS

SPLIT-COMPLEMENTS

TRIAD

TRIAD

COLOR PLATE IV

A variation of the complementary effect is possible through the choice of so-called split-complements. Two examples are shown in illustrations A and B on Color Plate IV, preceding page. In A, orange is combined with the two hues that lie next to its exact complement, these being blue-green and blue-violet. In B, blue is combined with its split-complements yellow-orange and red-orange. Split-complement schemes seem to appear best when the key hue is a primary (red, yellow, blue) or a secondary (orange, green, violet). As with true opposites, arrangements of split-complements have a striking visual effect and are universally liked.

In triad color schemes, shown in illustrations C and D, three colors regularly spaced about the color circle are brought together. Here color effects quite distinct from each other are possible. In illustration C, the triad of orange, green, violet is shown. This has a certain elegance not found, for example, in a more primary triad of red, yellow, blue. In the triad of intermediate colors, red-orange, yellow-green, blue-violet (illustration D) there is startling visual contrast. In the triad of yellow-orange, blue-green, red-violet there is a more exotic and oriental feeling. In all instances of triad schemes the whole of the spectrum seems to be reflected.

COLOR PLATE V

Illustration A on Color Plate V, following page, shows the harmony of a dominant tint. A scheme of stars in white, pink, yellow, and green on a soft blue ground is overlaid to the left with a tint of blue and to the right with a tint of yellow. Almost any combination of colors, no matter how discordant or haphazard, can be "pulled together" with the dominant tint. In nature, the sunset may cover the earth with an atmosphere of soft orange. Night seems bluish. Distance seems modified by a soft purple. Many old works of art have a warm mellow quality chiefly because the varnishes used by the painter have turned yellow over the years. The dominant tint can be accomplished with a transparent glaze applied with a brush or an airbrush. It affords an easy road to harmony.

In illustrations B and C, a unique "natural law" of harmony is demonstrated. To most persons the arrangement to the left (B) would be considered more pleasing than the arrangement to the right (C). Yet in both instances the colors used are yellow, orange, red, and violet. Here is how the law operates: where various hues are combined, those which normally have a high value (yellow) look best in tints, while those which normally have a low value (violet) look best in shades. Where the situation is reversed, where the yellow is made into a shade (olive) and the violet into a tint (lavender), the arrangement seems awkward and uncomely. *174442*

COLOR PLATE V

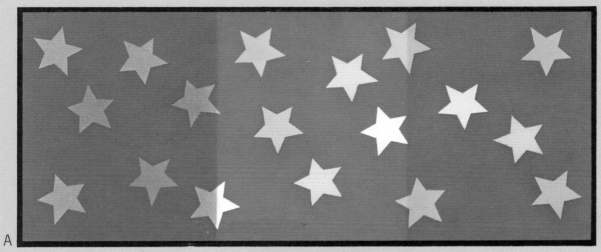

A

DOMINANT TINT

B

NATURAL ORDER

C

UNNATURAL ORDER

COLOR PLATE VI

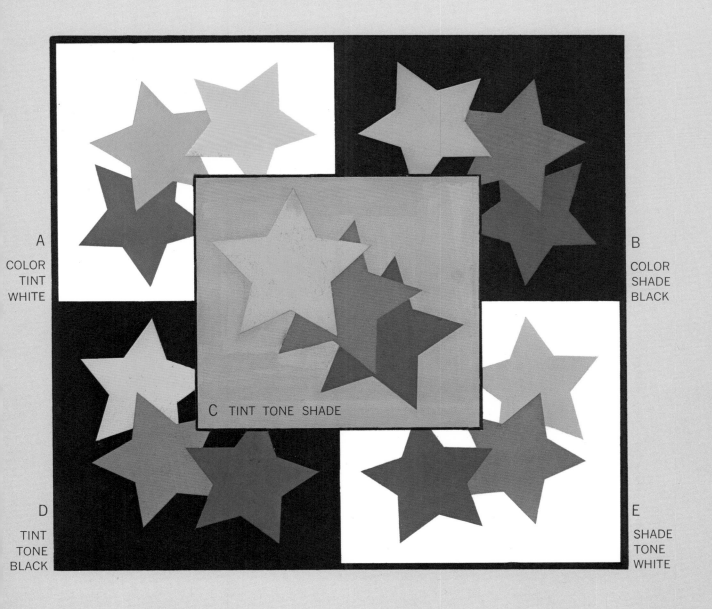

A
COLOR
TINT
WHITE

B
COLOR
SHADE
BLACK

C TINT TONE SHADE

D
TINT
TONE
BLACK

E
SHADE
TONE
WHITE

COLOR PLATE VI

The five color schemes shown on the preceding page all trace straight paths on the color triangle. (See Figures 36 on page 47; 44 on page 57; 46, 47, 48, 49 on pages 60-64, and accompanying text discussions.) Because color relationships on the triangle are natural to the way in which the human eye (and brain) react to the vast world of color, harmony is found where such relationships are neatly ordered. Using variations of orange, green, and violet, illustration A shows a combination of pure color with tint and white. This has a clean fresh look associated with the paintings of the French Impressionists. In illustration B, pure color and shade are combined with black. This was the type of color sequence often employed by Rembrandt. The effect is strong and rich. In illustration C, the path on the triangle is a vertical one from tint (orange) to tone (green) to shade (violet). The *chiaroscuro* style of the Renaissance is well expressed here, and the effect is soft and refined.

In illustration D, the path is from tint to tone to black. A similar path would be from tint to tone to gray. (See Figure 48.) Turner, one of the greatest of English painters, used this principle. The light colors are clean and the dark colors grayish. Illustration E shows an effect opposite to that of D. In E, shade is combined with tone and white. The light colors are grayish and the deep colors rich. The Spanish painter El Greco featured this arrangement.

COLOR PLATE VII

Four unusual effects for color are shown on Color Plate VII, following page. As discussed in the text, new principles for the creative use of color are to be derived from a study of the phenomena of human perception. Using ordinary art materials (watercolor) and ordinary reproduction methods (lithography, printing inks) remarkable illusions are to be achieved. By studying his own sense of sight, his own perception, the student of color can accomplish results that far exceed the normal appearance of the paints or pigments he uses. In illustration A, for example, an effect of luster is shown. The viewer is less conscious that he is looking at paints or printing inks than at silk or some lustrous substance. This is done through sequence into black. (Also see Figure 53, page 69.) In illustration B, the effect is one of iridescence or mother-of-pearl, an elusive phenomenon which, in nature, depends not on pigments but on the refraction of light. Here there is sequence into gray. (Also see Figure 54, page 70.)

In illustration C, an effect of luminosity is attempted. Yellow, red, and blue stars appear to shine forth in a blue sky. This is done by making the luminous centers of the stars the lightest and purest areas in the composition. (Also see Figure 55, page 72.) Illustration D is a convincing demonstration of an effect of transparency achieved entirely with opaque materials. (Also see Figure 56, page 74.)

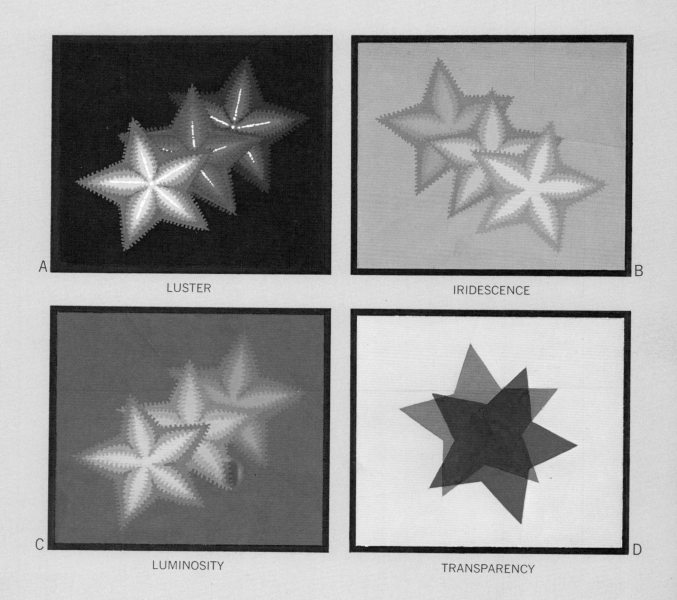

A LUSTER B IRIDESCENCE

C LUMINOSITY D TRANSPARENCY

CHROMATIC LIGHT EFFECTS

CHROMATIC LIGHT EFFECTS

COLOR PLATE VIII

The four illustrations on Color Plate VIII on the preceding page show effects of chromatic light. That is, in the original watercolors of the artist and the printing inks of the lithographer, nothing of luminosity exists in the least. If what is seen on Color Plate VIII appears to shine like light itself, this is due wholly to perception, to what the eye and mind interpret from the strategies employed in putting the color schemes together. The key to each effect is in the background. This gives a clue to the predominant light source. Other luminous touches are then added, and these in each case blend neatly into the color of the background. The artist is able to transcend his materials and to create illusions which go far beyond conventional and traditional color arrangements of the past. The shift in emphasis is from the design or composition itself (which the eye might focus as a mere camera) to a magical transformation in which the viewer takes active participation and puts into the composition much of his own fancy. This marks a new attitude toward color, a new domain in which artists of the future may enter and explore for a new and more dynamic art of color. In the past, the artist looked to nature for hidden secrets of color harmony. Now he will look within his own being and psyche.